We-gyet Wanders On

Legends of the Northwest

hancock
house

ISBN 0-88839-636-8
Copyright © 1977
Kitanmax School of Northwest Coast Indian Art,
Hazeleton, British Columbia

Printed in Indonesia - TK Printing
Production: Rick Groenheyde

Cataloging in Publication Data

Library and Archives Canada Cataloguing in Publication

 We-Gyet wanders on : legends of the Northwest / organized and compiled by
Kitanmax School of Northwest Coast Indian Art.

 Originally published: Saanichton, B.C. : Hancock House, 1977.
ISBN 0-88839-636-8

 1. Gitksan Indians--Folklore. 2. Legends--Northwest Coast of North America.
I. Kitanmax School of Northwest Coast Indian Art

E99.K55W43 2006 398.2'089'974128 C2006-900444-7

Published simultaneously in Canada and the United States by

HANCOCK HOUSE PUBLISHERS LTD.
19313 Zero Avenue, Surrey, B.C. V3S 9R9
(604) 538-1114 Fax (604) 538-2262

HANCOCK HOUSE PUBLISHERS
1431 Harrison Avenue, Blaine, WA 98230-5005
(604) 538-1114 Fax (604) 538-2262

Website: www.hancockhouse.com *Email:* sales@hancockhouse.com

Table of Contents

Words Before

Now we will tell you the stories of We-gyet in English and in Gitksan. It is unfortunate that much of the humor relies on a quick-witted play on words and well-known Gitksan phrases. Puns are frequent. Sound-effects are important and prolific consequently the English, written version occasionally punctures the fragile bubble of wit, myth and moral that surrounds each story of We-gyet's adventures.

We-gyet taught the people of the dangers of over-indulgence, greed, lust and laziness, always using the indelible print of laughter to ensure the survival of his fables. Even the name We-gyet relaxes the mouth into an expectant smile. *

There was no end to his adventures as he wandered through the years giving entertainment, and hidden advice, to a people living in difficult times.

*We-gyet rhymes with "be set." In English We-gyet means "big man."

We-gyet was the essence of all man's frailties exaggerated into gentle humor or ribald laughter. His misjudgements, his calculated transgressions, always ended in disaster. He thought only of the moment, leaving tomorrow's decisions to tomorrow.

We-gyet was craft without wisdom, power without regard for consequences. He was as unheeding and petulant as a spoiled and pampered child and yet often as appealing as an unloved one.

We-gyet's blunders, tricks and falsehoods changed the face of the earth and the shape of many of earth's creatures.

We-gyet closely resembles Raven, the Trickster-Transformer of Haida and Tlinget history but with this difference: our Raven, alias We-gyet, never creates; he manipulates, duplicates, instigates and disseminates but never creates.

We-gyet was caught between spirit and flesh. He was no man, yet all men.

We-gyet Wanders On

The Childhood of We-gyet

There was a man named Hu-will who lived on the Coast.

Every fine day he went to sea in his canoe to hunt for sea otter and other creatures of the water who permitted themselves to be captured by human beings in need of food or clothing.

One day, as Hu-will pulled past a bed of kelp, he was sure that he heard a baby crying.

"It can't be a baby," he said to himself. "How could a baby swim out to that kelp bed?"

Then came chilling thoughts. "Perhaps it's a warning....Perhaps a *lulak*...a Power not Human....Did I fail to obey the laws of Nature....Did I treat with discourtesy the People of the Big Water....My heart holds fear."

Hastily he struggled to reverse the canoe. As he swung around, he got a better view of the kelp bed. In it lay a baby! A tiny baby boy and he was crying his heart out. Hu-will's fears for himself changed to concern for the baby.

"I don't know how he got in there," he said aloud, "But I do know that he needs help to get out."

Hu-will swung his boat around, paddled rapidly to the kelp, reached over, lifted the baby up and gently placed him in his canoe.

Then he hurried back to the village.

The villagers accepted the baby with goodwill. Everyone offered help — shelter, clothing, food. Many types of food were offered but no matter what was brought the little fellow refused to eat one bite.

Day after day he refused to eat, yet day after day he grew bigger and bigger.

"How can he grow without eating?" the villagers asked each other. "And grow so fast, too. He is almost big enough to go hunting." Puzzled and troubled they tended the unusual boy as best they could.

One day a stranger came. He was tall and thin and as he stepped from his big canoe the people could see that he had rough scaly legs.

Kindly Hu-will greeted this tall visitor and invited him to share the food that the women had prepared.

Naturally, Hu-will told the guest of the strange boy who rejected all food yet grew at such an amazing rate.

"Let me try to feed him," the stranger offered and lifting the boy to his knee gave him some fish.

The boy began to eat!

Those in the household of Hu-will could not believe their eyes! They were so pleased and excited that only one wise and observant old person noticed that the stranger kept reaching down to his scaly legs as he fed the child.

From that day, instead of refusing food the boy constantly craved it. He was never satisfied. His foster-parents, his friends, the whole village worked frantically to keep up with his great appetite. They gave him all they could but it was not enough. The boy grew bigger and they grew hungrier.

Finally, in desperation, the chief ordered everyone to leave the village, to leave the "boy" who was now bigger than anyone in the village, the "boy" who was bringing them to starvation.

The villagers reluctantly obeyed. They packed their belongings and slipped away.

The huge fellow was alone. Soon hunger forced him to leave the village too and search for food.

Thus began a long journey that would never really end, the journey of We-gyet.

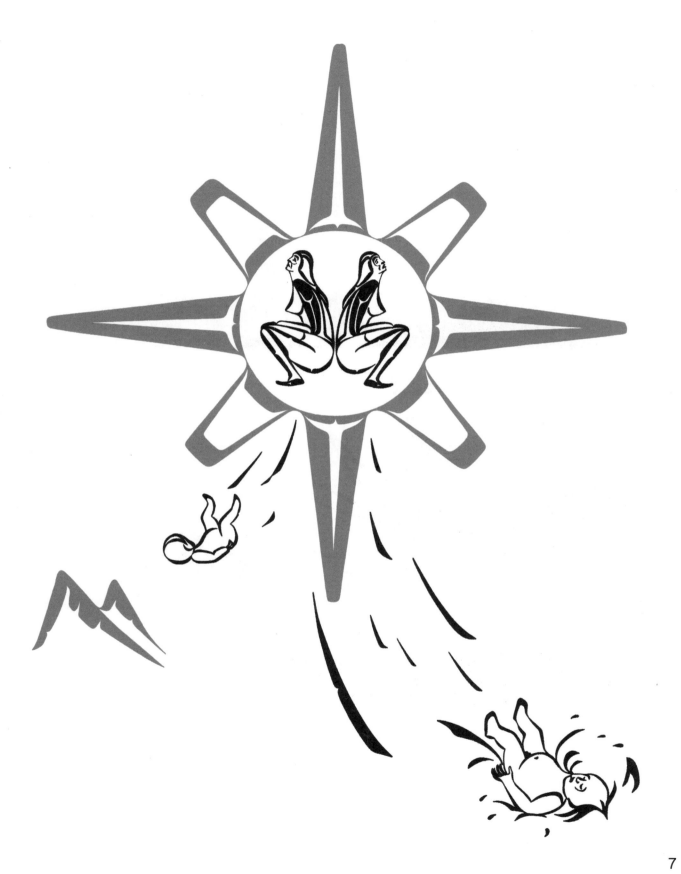

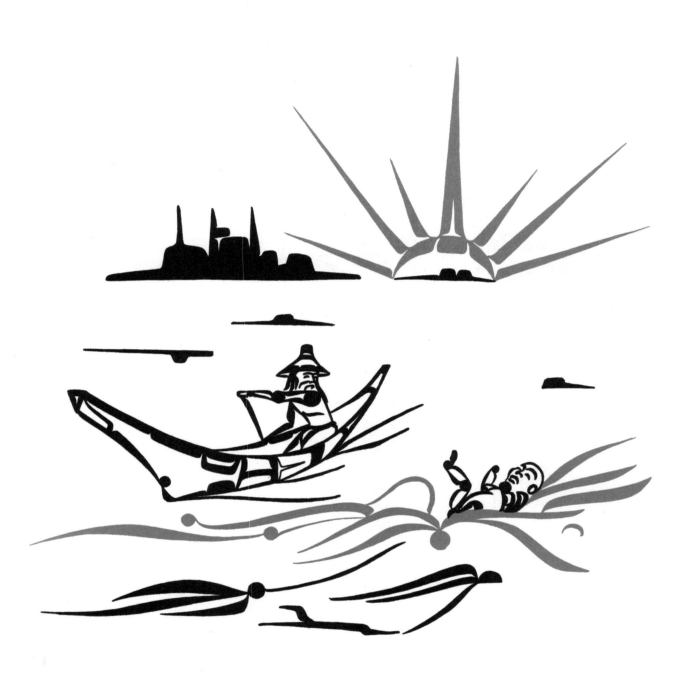

Wil'Sit' Aatxws Wii-gyat

Laẋ mo'on wil joẖhl kyul'hl gyat siw'at'diit as Huu Wil mahla k'iyhl sa kwi yo saa sigyootxwt m'alhl hooy'tk'woo sin el'ẋt. Wineex gahnl am hax o'git wilt hooxwhl kwoo yajasxwt.

Kiy'hl sa bagal'gy naẋniy't wil waat'xwhl hlgutihlxw hlaat gila yuxwhl mooẖ hehl ap' gyaẖal gadixsidyhl het. Yugumahl nigidiihl het diiyahl t'ilẋhoo'at. Luulaẖhl amgoodiit.

Hats'im gyipgyabithl gal'bits' iit kwihl sikihl guuxws di wa'ayhl m'alt, ii hlaad kwit'ku di yukwhl mal't di asp'a gya'at hlguts' uusxa t'ihlxw. Ii sim k'yaa t'ishl waat'xwt ii guuxws waaxs Huu Wil goohl mooẖ iit tẖa loẖan guudihl mooẖ wil n'iitaahl hlgu t'ihlxw sa, goohl ts'im m'alt iit guuxw digyoot goohl ts'apt.

Luu am'amhl gagoothl hla gyadihl ts'ap iit luu dal'txwdiit, hlgutihlxw. Lipligi aagwihl gwindadoẋdiit wineex ganhl k'ixdas. Gwin diliyeediithl t'ẖanit'xws wila jipjabihl wineex ii ap' needi nim yookxwhl hlgy tihlxw sa. Mahla kiyhl sa ii ap' gani nit'hl wilt needi n'im yookẖwt. Ii ap ganwila m'as ahl wilt. N'dahl wila m'asta yukwhl' needi yookẖwt diihiidah hla gyadihl ts'ap.

K'iẏhl sa bagal'gi kyatxsw ẅii xhli am'al'gwidhl gyat ho'oẏthl m'al. Sim xhlii amalkwt sise'et, wilk'iit ts'im'il uu'w'es Huu Wil ẅii nakwgwa gyatsa ts'im wilpt ii wo'atxwt loot. Iit mahlas Huu Wil wila wihl hlgu lixsgadim t'ihlxw ant at'dii n'im gubhl wineex.

N'dee'ehl hlgut'ihlxwis looy' dii yahl w'ii nakwgwa gyat sa, iit n'ii taadihl hlgutihlxwsa laẋ see'et ii yukwt gen'aẋt, ii sim min'luxwlukwhl gyat an't gya'a wil yookẖwhl hlgu t'ihlxwsa. Hats'im ji ts'ahl'ẋ yukwhl yookxwt. Ii sim luuam'amhl gagoothl hla gyadihl ts'ap wil yookẖwhl hlgutihlxw tun. Neediit n'aa ja'ant gabidn't am k'yul guuxwẋhoo'osxwit gyat an't gya'a wil saa daẋt'ogahl w'ii n'akwgwa gyatsa ahl si se'et iit ho t'ẖal luu magat ahl ts'imaaẖhl hlgut'ihlxw sa.

Ii n'it laẋ sa t'ust wil sit'aam'ahl yookxwhl hlgut'ihlxwsa, ii needi n'im ts'eext gani yookxw anẋsnigwoot'xw ganhl t'ẖa nit'xw gap'ẖap'xwt an't baẖ dimt ts'eey'nt iit gosdiit hats'im geey' xwdax. Hla sim t'ẖal yeehl gasoohl ẅii t'ihlxwsa ii hlaat jahl wineexhl tẖap'aẋ k'iyit'xwsithl gal ts'ap.

Il algyaẋhl sim oogitsa ahl hla ts'apt am dim huudim diiya, dim laẋhlaẖ'ehlẋt n'u'um ji gayee ji wan'im ii sim ayeehl siisaẋwhl galt'sap ii adoẖsdiit ii huudiit ii am gina k'wihl k'yuls Wii Gyat. Needi n'akwt ii hot'y k'wihl yeehl git'xst adim gubit' ii needim dii sabaẋ dim git'xst ahl wineex ganwila kwihl yeet siwadim as Wii Gyat.

We-gyet and Bullhead

One day We-gyet wandered near a river.

Glancing down he saw the fish that people of today call "Bullhead." Bullhead swam close to the riverbank sadly opening and closing his wide, drooping mouth as he swam.

"Food," thought We-gyet. "That fish could fill a corner of my empty stomach. How can I capture him?"

We-gyet made a plan. He knew that he must not startle the fish. He took his time. A fisherman must take time.

Casually he bent over the water and held out a friendly hand, palm upward in the accepted gesture of friendship and goodwill.

"Fine Swimmer, your mouth reminds me of my beloved Uncle, the Uncle I so greatly admire," We-gyet cooed in a voice as soft as the finest eagle down in a chief's pouch.

The fish paused. He swam close to Soft Voice.

We-gyet's friendly hand shot forward and snapped the Fine Swimmer out of the water and up to the fisherman's hungry lips.

The frantic fish squirmed wildly, struggling desperately for survival. He lurched to the right. He lurched to the left. Right. Left. Right. Left. Then he shot forward and up like a great killer whale and, aided by his slippery coat, he slithered out of We-gyet's grasp.

Bullhead was free. He was on his way back to the water.

But We-gyet was not going to let this tasty morsel escape so easily. He was hungry, so hungry.

Lightning-like his arm again flashed forward. Bullhead's mouth was already in the water but We-gyet's big hand took a stranglehold on Bullhead's body and jerked the fish back. We-gyet now clung desperately to his quarry, squeezing the body and tail until they almost disappeared and forcing the poor creature's head to swell and expand until it bulged like a giant puff ball. *

Pain and terror spurred Bullhead to supernatural effort. He gave a monsterous, fear-inspired heave and wrenched free of We-gyet's strangling hold.

Splash! Bullhead was home in the river!

Swiftly he raced from the shore.

From a safe distance he turned his now bulging, over-sized head and distended eyes toward his betrayer, saying accusingly, "Who doesn't know you, We-gyet?"

Since Bullhead was far out of his reach, We-gyet went disconsolately on his way.

To this day the family of Bullhead sadly carry the ugly, swollen head and tapered body shaped by We-gyet's hungry hands.

*Our word for puff ball means "ghost's droppings."

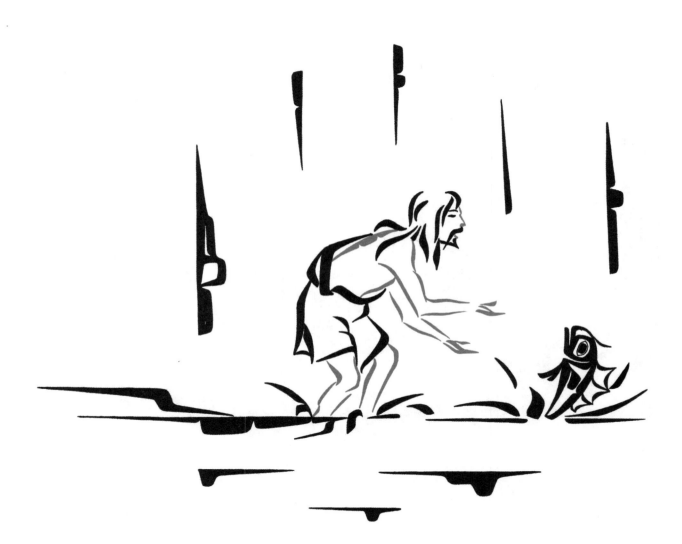

Dip Wii-gyat Ganhl M'askaya'ay

Luubayt kwihl yeet Wii Gyat ahl lax ts'eehl aks ii t'ip gyal'asxwt, it gya'awil kwihl gyoohl rhas kaya'ay (hoen suuwadihl amxsiwaa ahl satun ahl *bullhead*). Kayem kwihl gyoohl Maskaya'ay tun ahl wat's lax ts'eehl aks, wihl ligi dawihldihl goot kakganhl ts'imaakt it hoxsimo skahak'wagant ii sim t'ip hislisxwhl rhimkt.

Wineex dii yahl goots Wii Gyat Maskaya'ay tun dim ant luu midrhhl amhl hlgy luu ts'usxid ahl bany. Ndan dim wila mukwida. Ii sigootxws Wii Gyat wila ayt wil needit sgidimdiit ts'aagyuksinhl Maskaya'ay tun, ii sim hagwiligi kwihl wilt awil ap nithl wihl dim ii wit dim sim hagwilhuu wilt.

Ii hagwiligi t'ip xhlaa skitxwst ahl hlax ohl aks t'uxws yugwihl gwaat's hisguu ama gyatxwithl anont. Minxslaxotithl ts'im anont awil nithl anookwit tun alohl dimt wila yugwihl anonhl amagyadit.

Niin ant wilaaxhl gyoo. Ii ts'imaagan ant amgoosiny alohl ts'imaakhl rhibiby nihlnithl rhibiby tun sim k'yaa siip'ny dii yat', Wii Gyat a'asim gwe'eyt hla algyaxt, hogyaxwit hl ga gwe'ethl hla kaaxhl ts'uuts, luu do'ot olahl ts'im gwe'ehl sim-oogit. Ii gidi gyoohl Maskaya'ay ii sim ama gyadim anons Wii Gyat gihl hlo'odit t'ukhl an wilaaxhl hadixs gi xsi t'ok'ot ts'im aks it wil gi rhindidawihl ahl ts'imaakt, ii sim kyaa ts'aa gyuksxwhl Maskaya'ay t'un ii kwihlo'otxw saam lipligi luu bagayt kwihlo'otxw gasgoohl sikihl kyeekxwst dimwila mootxwtt.

Guuxws ts'aa rhakxw ahl anuu sim ont, iyoo guuxws ts'aa rhakxwt ahl annu sirh anuu rhat'uxw ont, goya goohl sim ont, goya mat'uxw ont, goya sim ont, goya rhatuxw ont. Ii saarh daxgyathl xsihlo'otxwt. Ndahl wila wihl guu jagwsxurh n'eexhl ii hla amhl gan n'akwt, ii ma'ooga'hl hla t'kat, ii rhit wil gas xsi hliksit ahl an ons Wii Gyat. Lip gyathl Maskaya'ay tun, ii hlaa lok'anyukxwhl guuxw yeet' tsim aks ii ap needit anooks Wii Gyat dimt wut-s'agal' dim wuts'agal' kaspa kwoodinhl hiyugwid dim gubit.

Awil sim luk'wil xwdaxt, saam xwdax nit, ii rhdahl wihl hurhax nithl wiwil hots'imo yeehl ons Wii Gyat.

Hla hlisxwhl lokarh akhlxwt ts'imaakhl Maskaya'ay tun, ts'im aks diswilt hoksimo gidiguuhl wii ons Wii Gyat ii sim git daxyugwhihl hla hlats'xhl Maskaya'ay tun iit guxws darhgarht ii simt hooxhl hlit daxyugwihl hla anu angalanhl Maskayay'ay tun.

Saam da'arhxsit ii wak'hl hla an galanhl Maskaya'ay turh am hlisdo'ohl yagayt di gasgoot nithl gasgoohl an galant. T'imgest m'as i rhast, i rhast hogyaxwit wil rhashl rhasxwa luul'ak gasgoohl siipxwhl bagat ii xp'ats'axw nit gan wihl aatixs wil hogyaxhl Maskaya'ay tunhl nax nok, hogyaxwithl simil'o'o, gasgoohl hla xp'ats'axwt ant ganwihl saam d'arhsxwt ii xsihlo'otxwt ahl sim gitdax yuuwas Wii Gyat baxwhl aks wil luu de'et ts'im aks ii sim k'yaa t'e'elt uxws gyoot, xhlamakithl lax ts'eehl aks, ii hlat wil aax wil amhl ganakwhl wayt dim ootxwt ii gas guuxws gya'al'asxwt hlwii git'xwidhl t'imgest ii xsa gas goeshl t'sa'at ii sarh alaxt ii het. Naat'an awilayina, Wii Gyat nithl n'it gan wihl t'imgeshl Maskaya'ay wii asgit ii, wii layt ii sahl gu'ul'hl hla anu hlatsxt xsax, sip. Needi n'ii hoendit.

13

We-gyet and His Raven Robe

We-gyet journeyed on. He was wearing the tattered raven robe which had belonged to his father, the robe we call *gwees gaak*.

In a tall tree he saw three well-fed bears. The sun smiled back from their black and glossy fur.

"The fur of those three bears would make a handsome new robe for me," thought We-gyet.

He stood at the foot of the tree and gazed at the motionless bears. His vivid imagination pictured the fine, new bear robe in every detail. He saw himself large and impressive in the fur of the bears, a man of obvious wealth and importance.

He flung off his *gwees gaak* thinking, "I won't need this anymore. My new bear robe will make this worn feather thing as useless as last year's nest."

So he tore up the raven blanket and gayly trimmed every nearby tree with the feathers.

Then, armed with nothing but his high hopes, We-gyet took a stance within range of the treeful of bears. Gleefully he jumped up and down, up and down, singing a song which he composed as he eyed the bears.

"Weh, Weh, Weh, Weh,
I will have a robe of three bear skins!
Weh, Weh, Weh, Weh!"

Whereupon the smallest of the three bears, not wanting to become part of We-gyet's wardrobe, scrambled off the tree, lumbered out of reach of the singer and disappeared among the bushes. We-gyet adjusted easily. He changed his song, never missing a jump.

"Weh, Weh, Weh, Weh,
I will have a robe of two bear skins!
Weh, Weh, Weh, Weh!"

Another bear scrambled out of the tree and he, too, disappeared among the bushes. We-gyet, still unruffled, sang,

"Weh, Weh, Weh, Weh,
I will have a robe of one bear skin!
Weh, Weh, Weh, Weh!"

The third bear scrambled out and galloped off to join the others. We-gyet took his breath in to sing. No suitable words came to him. He realized that he had no material for a new verse, no material for a new robe. And no worn, old *gwees gaak*.

No longer jumping, he slowly trudged from tree to tree, retrieving the feathers he had cast away so happily. Slowly, painstakingly We-gyet tied the scattered feathers into a second *gwees gaak,* more tattered and misshapen than the first, and journeyed on.

14

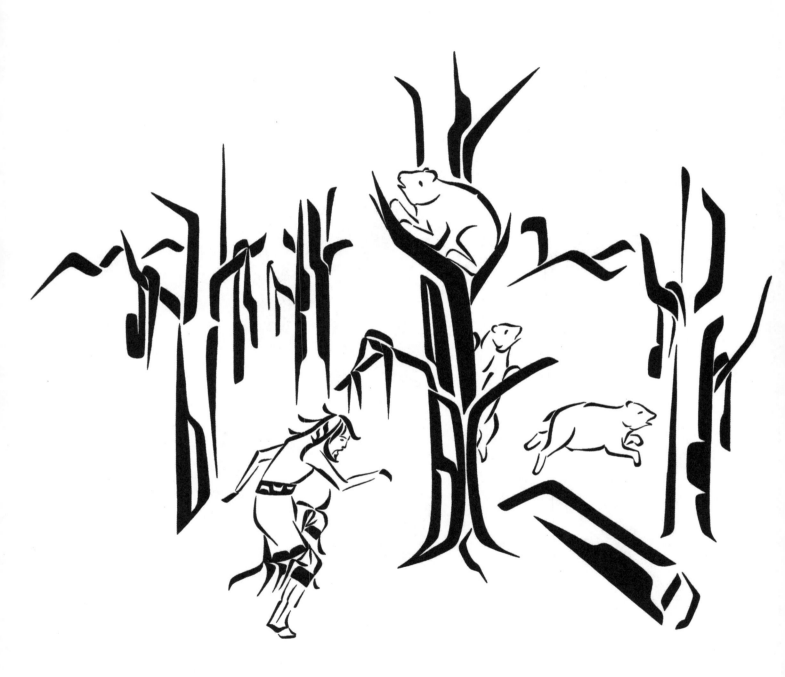

Gwiis Gaaks Wii-gyat

Luubagay̓t kwihl yeet Wii Gyat sim ak̲hl hehl goot't. K̲k̲ihl hoy̓thl gwidat's suwat'm ahl gwiis gaak̲ hii yukwihl wilt, diswit gya'awil ṅii wanhl sim smax lax̲ arhal' gwlahhl gabihl smax dipun'.

Wihl ap guuxws ts'ahlx̲adihl hlox̲s wilt tk̲al' gunwihl hlagal' laxhl smax sa. Hats'im dildilxw gasgoohl hla nook̲s Wii Gyat ahl smax dipun'.

Nihlnithl hlagatk̲ahl gwil'annt smax dim an suu gwidats'xwi diyahl sigootxws Wii Gyat.

Gya'as Wii Gyat wil sim needi hlinhlantxwhl smax sa. Wilaayhl smax dipun' hehl tilx̲ho'oas Wii Gyat dim sigwilat'xwt hla tkahl smax sa dy̓ahl het.

Hat'sim lip gigya'as Wii Gyat dim wila jabit jihlaat' hooxhl dim sigwidats'im smaxt, gasgoohl hla hooy̓sxw dimil' kwihl yeet'.

Neeṅ dim hoty hooxws sun dii yat Wii Gyat iit gyak̲al guuhl gwiis gaak̲t iit suuwy̓ l'al'dṅt. Wihl ap logam anda hlguuhlxw tsuutsjihl wila jabit, iit nii yaxyak̲t hla k̲aaxhl gaak̲sa lax gangan.

Sii gwidats'im smaay̓ dim hooy̓ nit dim ant sa al'uutaa wil hlgu wilksihlxw hi, dii yahl guuxs, didalkxws Wii Gyat, hats'im ji ts'ahlx̲ hi y̓uhhl het.

Hats'im kwihl miilxwt Wii Gyat gaswil gost iit sirhaadihl wil ṅii wanhl smax sa la'am rhal'. Silimxdithl gwlanthl gabihl smax sa.

Needi gwihl ẇaja yukuwdit dim an'wil lȧaẇat amxsa hla, ẇii sigootxwit gasgoohl hla xshlax̲ahl k̲'o'omgasxwt.

Gya'as Wii Gyat wil nii wanhl gwl'anthl smaxsa, ii sim hisẇeesxwt. Gwl'anhl gabihl smax dim sigwidatsxwy̓ diyahl limxt ẇe, ẇe, ẇe. Sa'amhl hiyukhl het disat'ip' k'yeek'whl glgu ts'uuxid smax sa, neediit hasak̲t dim ansigwidat'sxws, Wii Gyat ahl hla tk̲at. Needi am gabitxw ji wila da'awihlt.

Ii ap neegiligi an gwis Wii Gyaťloot, hats'im am sidyeexwdihl limxt neegili k̲'aluu giishl gost, ẇe, ẇe, ẇe. Niy̓dim sa gwidats'xwid ahl t'ip'x̲aadit smax sa diyahl silimkst. Sa amhl hi yukwihl het, di yoot'i sat'ip kyeekwihl ts'uu t'ipxaadithl smax sa, hats'im am hlinhlantxw y̓ants wil da'awihlt.

Ii ap needi sa yeehl goots Wii Gyat ganiligi nithl limxt. Niy̓ dim sigwidat'sxwt ahl am keekwidhl smax sa ẇe, ẇe, ẇe hi yujwihl het ii sat'ip k'yeekwhl ts'uu gwlanthl smaxsa gȧs luut'aahl goots Wii Gyat ak̲hl ho silimxt't, gwalim'i laax̲ts'a yeehl hla naahlx̲t. Wilaay̓t wil ak̲hl ho'oy̓t jit jap'hl sii gwidats', ii neegyot'y gost gyuu'n, neegyot'y skihl logam gwiss gaak̲ loot. Am si amhl yees Wii Gyat saxdo'othl hla logam kwasihl gwiis gaak̲t dim hots'imo hoy̓t sim gahl k̲eehlit sise'et gasgoohl hla da'wihl goot't ii hots'im luu bagay̓t kwihl yeet.

We-gyet and His Wife

We-gyet's fortunes had changed. He had found a wife who supplied him with all the food he could eat! We-gyet gorged and gorged on salmon, yet for every salmon he ate his busy wife hung two new ones on the drying racks. They had houses full of dried salmon. Whenever his wife went fishing salmon miraculously appeared at her feet.

This wife was not only busy, she was beautiful. Her flame-colored hair sparkled like those chips off the sun, the stars. We-gyet greatly admired this hair and wished his could be the same.

We-gyet's wife knew, without being told, that We-gyet wanted hair like hers. So because she was *nax nok** and because she loved the Big Man she had married, she gave We-gyet hair that gleamed like her own.

We-gyet was so happy! A good wife, a full stomach and radiant hair! What more could a man ask? His journeying seemed at an end.

One day, as he walked through the smokehouse, a drying humpback salmon caught in his hair.

Quick-tempered We-gyet tore the humpback off the drying bar on which it hung and flung the fish to the floor where it landed among the ashes.

As We-gyet did this, he spoke roughly to the salmon. "You of the big, ugly hump, how dare you disturb the order of my fine, red hair. The ashes are too good for you, clumsy, careless one!"

Without saying a word, We-gyet's wife put down her cutting tool and left the house. She walked to the water. There, making a sound that was half whistle and half the moaning of the surf, she disappeared in the water.

When she gave her whistling call, the fish in the houses came to life and one by one they followed the red headed woman into the water. They never came back.

As the fish disappeared, We-gyet's hair began to fall out. "Don't, hair! Don't, oh don't!" begged We-gyet. But the hair continued to fall. It lay on the ground in a pile. We-gyet picked it up and tried to replace it on his head but his own black, coarse hair had grown back. His own hair seemed very ugly indeed.

Too late We-gyet realized he had committed an unpardonable crime, he had broken the law that decreed that no one must speak roughly or rudely to a creature of nature. As a punishment, his good fortune, like his wife and his hair, had vanished. Sadly he journeyed on alone.

*Supernatural is a close English term but not exactly right.

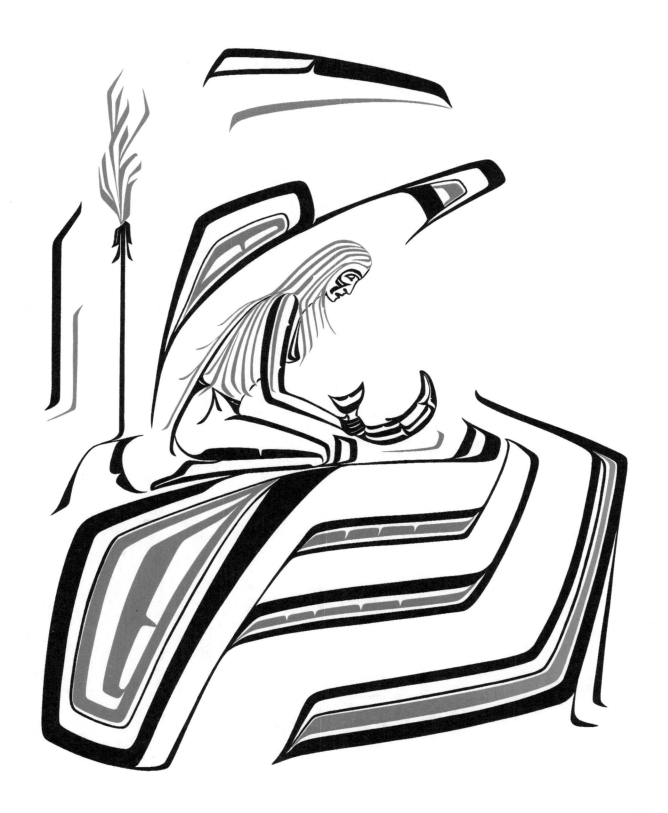

Wïi-gyat Ganhl Nakst

Gasligi sit'yeek'ws hla didil's Wii Gyat wilt sga
w'ahl nakst, gasgoohl hla gwil'ookhl hanak tun, ii
sim mit'xwhl wineekst ahl hoen, ii sim nisweesxws
Wii Gyat ahl yookawt. Mahla kiẏhl hoenhl gub'it ii
t'ipxaat luusit'yeewahl nakst loohl lisat'.

N'dawil sin hoenhl nak'st ii hatsimligi sagam
guxwguu'wasxwhl hoen wil het'xwt.

Needi amxsa gwil'ookhl hanak tun t'kal sk'ihl sim
k'yaa ama m'ast, wihl ap l'agwihl hla gest, wihl ap'
wil mihl hloxsi wil kwihl yal'txwt. Gasgoohl hla
nooks Wii Gyat ahl hla geshl nakst ii hot'y hasakt
dim iwihl lhla gest'. Neediit' naa ja'an't mahlat'
loot iit ap' wilaaxhl hehl t'il'xho'oas Wii Gyat.

Ii goẏa dii wii o't as Wii Gyat iit gin'amhl dim
hot'ẏ wihl hla ges Wii Gyat wila jabihl hla lip gest, ii
sim lukwil luu amhl goots Wii Gyat.

Sim kya luu amhl goots Wii Gyat, am'a m'ashl
nakst, ii ganwil'a mitxwhl bant, ii am'a m'ashl hla
gest. Gwi dimo hasagay'a diyahl guuxws gidaxẇt'.

Kiyhl sa ii gal'xsi yukwt ts'im wil'psihoen sim gidi
hakwihl hla ts'ip' muxwhl st'im'oon hla gest,
gasgoohl hla hal'ak'wsim goots Wii Gyat iit suuwẏ
sat'ip saa'yhl hap'ts eekxw'm st'im'oon.

Hats'im al'gyax yukwhl wilt. Ii het', n'dahl wihl
w'ats' w'ii duuhlt tun diiya iit xsn'ats'xt ts'im aat,

hats'im buxwhl aat wil de'et gay k'ya amhl ts'eedixs tun lun, diya.

Gya'ahl nakst'hl wilt ii needi xsdalt'xwt hats'imligi makdithl anooy'am k'ohlt, ii xsi da'awihlt ii y'aga daaw'ihlt lax ts'eehl aks. Hehl ap' hahlutaxxwidiihl aks, t'week'sxwihl hehl gitŵ ingadihl al'gyaxt' ii l'ok'an daawihlt ts'im aks hlishl het.

Wilk ii aat'ixs wil hots'imo dildiljihl hoen dipun' iit lok'an hilandiithl hank tun ts'im aks ii hla lok'an goothl hoen sa ii aat'ixs wil hlo'ohl hla ges Wii Gyat, ii sim dal'hl ŵii ts'im maakt ii het, ha'awit ges, ha'awit ges, hats'im kwihl dagosasxw yukwihl het. K'woka sikihl t'kal' daxdakdiithl hla gest. Hats'im gay gyakal ts'o'o.

Hats'im hlap' wil m'inxhla doxt, haldim, dogat' iit sik'ihl hooyt ii ap' nee, hlishl guuxws limxsihl hla lip gest. Ii sim xya asgit wil't lip' gya'at. Gay xsgal'an'im luu t'aahl goots Wii Gyat, ii akhl wilaa guuxws guudihl het.

Hlisxw wilt ii hlangsxwt wilt laaka dal'khl yajasxw. Kyaa naxnoonx tka nit'xws yajasxw n'it gan wihl neediit na dim an't haakanhl jagwasxw. Ndahl wila kwootxwhl nakst n'ithl wil'a saa goodihl hla gest. Ii hots'imo luu bagayt kwihl yees Wii Gyat.

We-gyet and the Halilaa

We-gyet journeyed on and on.

Then, ahead of him, he heard laughter.

He came to a grassy clearing where children were laughing as they tossed back and forth delicious chunks of the inner fat of seals.

As We-gyet watched he saw that anyone who dropped the seal fat had to sit down. The last player left standing could keep the fat for himself.

When We-gyet saw how the game ended he quickly asked if he might play the seal fat game.

The children looked at the over-sized man and decided that he would not be too much competition. We-gyet began to play. He surprised the children by rushing madly around, catching the fat again and again. The children would have been even more surprised if they had noticed that he surreptitiously bit off great mouthfuls of fat before passing it on.

Soon, thanks to We-gyet, there was no fat left to pass on.

"What's happened to our seal fat? Where has it gone?" the children asked each other.

"Which of you is hiding that fat?" demanded We-gyet, looking accusingly at each child.

No one answered. The last chunk of fat had disappeared.

The game was finished.

But We-gyet was not finished. Casually he inquired, "How do you get that seal fat?"

The leader of the seal fat game answered him.

"Travel to the next village and go to the chief's house in the center of the front row of houses. In that house is a *nax nok* who sits in the middle of the rear section. His name is Halilaa.

"Ask the chief if you can borrow the Halilaa. The first time you come near the Halilaa he will snap at you. Say, *'Lip angiadiniin nax nok.'** Then gently lift him down. Borrow a canoe. Perch Halilaa on the sharp tip at the prow of the canoe. Row out in front of the village. When you are well out in the water speak to Halilaa. Say, *'Jiixw Halilaa!'* (In our ancient language *jiixw* meant porpoise.)

"Then Halilaa will dive down and come up with a seal. He'll eat the seal. Then you say, 'Jiixw, Halilaa' again. He will dive again. He will come up with another seal and he will eat this one too. Be sure not to talk to him while he's eating. Keep him diving and eating until he can't eat any more. Then you say, 'Halilaa, you forgot your partner.'

"Then he'll go down again and again and bring up seals 'till they fill the canoe. These you may eat."

We-gyet promptly began to carry out the leader's instructions. He went to the chief and asked if he might borrow Halilaa for a short while.

The chief said, "You may take him for awhile but be very careful with him. Be sure not to talk while he is eating."

We-gyet took Halilaa down gently and sat him in the canoe exactly as the boy had instructed. Then We-gyet rowed out in front of the village and commanded Halilaa to dive.

"Jiixw, Halilaa!" We-gyet ordered.

*"I am your master, Great-Power-Beyond-the-Human."

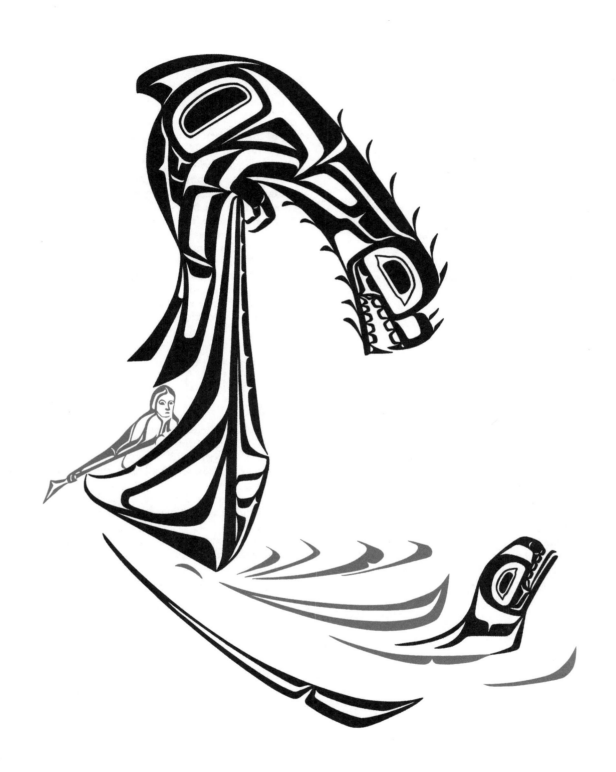

"Halilaa obediently dived off the nose of the canoe and swam back in an instant with a nice, plump seal which he began to devour.

"Jiixw, Halilaa!" We-gyet commanded again and Halilaa dived for another seal.

"Jiixw, Halilaa!" and once again Halilaa sprang off obediently.

But We-gyet himself was not so obedient. He could never remember to be silent nor would he obey instructions. He was tired of waiting in silence while Halilaa feasted so he made a plan: he would frighten Halilaa's appetite away!

Lowering his voice, We-gyet produced a mournful wail that seemed to come from ghostly fathoms below.

"Halilooo-ooo-oo-oo...."

Quick as a hummingbird but vicious as a mountain lion Halilaa pounced on We-gyet and tore the Big Man into bite-sized pieces which he discarded disdainfully in the water.

When there was nothing left of We-gyet to cast away, Halilaa returned to his master.

But We-gyet, who was a living textbook for our people, was not allowed to die. At the bottom of the deep he drew together, flesh to flesh and bone to bone until he rose whole from the water.

Slowly and painfully he limped on his way.

Wii-gyat Ganhl Hal'il'a

· Luu bagayt k'wihl yee't Wii Gyat, ii aym' migwilt' wilt naxn'i wil ha'hehl hishal'agyaxxwt. Iit ẇahl ñiialax am wil yukwhl gal'aaḵhl k'ubut'ihkxw, an m'as oes diit'hl hi'ya elx, hats'im laxts'aa hal'al'dn'diit hixsa.

Ilt gya'as Wii Gyat naa an't gal'ohl hix iiyo t'aat', naahl gina xsgala'an't nit an't sida dogahl hixsa. N'ithl gya'as Wii Gyat ii hot'y n'im huk'wsxw.

Il gya'ahl k'uba t'ihkxwsa ẇii gasgoos Wii Gyat iit anooḵdiit dim hot'y huk'xwsxwt', neem' dii kwihl aa ḵolxt dii yahl hediit, ii sim' m'inl'uxwl'uḵwdiit gasgoohl'a ay'ees Wii Gyat at' xbit'daxt'oḵhl hixsa.

Il gas wil am'ts'in sa'hashats'it, k'woo sim midn'thl ts'imaaḵt hlagooḵ dim diit hal'al'dnt't.

Sa'amhl yukwhl wildiit da goodihl hixhl an'galaaḵdiit, nda wil sakshl hix'gi dihiidihl k'uba t'ihkxwsa, aḵhl hoo anm'as'oesdiit.

N'it wil hes Wii Gyat loodiit, naa, loosim ant gay lil'iixwthl hix'gi diya. Neediit naa ji xsdal'txwit, nit, wil gas het.

N'dam wil sim ẇahl hla hixhl el'xsa, diya, w'ats' luusingidaxdithl k'uba t'ihkxwsa.

Ii miin'txwdiithl al'gyagat', dim yee n'ii goohl gal'tsap'is diya, hla silkwhl xsgoogam t'ahl'twilp,

wil hetxwhl wil'phl simoogit wil luutaahl naẋ noḵ
baġayt ḵal'aan' wil t'aahl siwat'xwit ahl Hal'il'a.

Sim nit dim'wil gwin yuk'w'n loot dim hii lin't, ii
tun dim hen' loot, lip angigyadn', Naẋ Noḵ midim
tun, ya'an. Hlisxw dim hen' midmii am'si'am
midim t'ip guud.

Dimy' gwaasxwin ahl m'al, midimy' n'iitaadihl
Hal'il'a ahl hla gits'eegahl m'al'is. Hlaa uxws
n'akxw dim wa'ay'sim dimy' hen' jiixw, Hal'il'a,
midim' ya'an dimy'o t'akshl Hal'il'ay's hlaxwhl aks
miit ho m'indiw'it'xwhl el'ẋ ii yukw dimt' gup't,
dim jahl'it, dimy' hots'imo hen. Jiixw Hal'il'a
dimy' hots'imo t'akst, dim hots'im m'in diwitx-
widhl el'ẋ, ii sim ha'm' ji didal'ḵt yukw ji yooḵẋwt'.

Dim ap' wagayt wil ma'wil wilaax wil ts'eexhl
Hal'il'a'ys dim gas hen'. T'ak'in hla daadin Hal'il'a

dimiit min'wilgahl elẋ. Wagayt dim wil mitxwhl
m'al n', diyahl yuuhlimẋhl hlgu tihlxwsa't Wii
Gyat.

Il ap' gasgoohl hla ints'asxws Wii Gyat. Hlat gya'a
wil yukwhl yookxwhl Hal'il'a. Kay ligi k'yeekxw
diihl el'ẋhl gubihl Hal'il'a di al'gyaẋt Wii Gyat.

Tak'n hla'daadin Hal'il'a. At'w'at saasgihl am'et.
Haniigoot't dim't saẋp'ts'axw Hal'il'a.

Si'amhl yukwhl het di gumẏ he'hetxwhl
simil'oo'a'sa, sil'ga'ayeetxw sithl ts'uuts iit hogyaẋhl
ga'al'axhl laa guk'sithl haw'ow.

Hats'im ligi xliibisbisith lismaxs Wii Gyat. Iit
loḵan mit'aẋst ts'im aks, sim loḵan goodin't. Iit
ap'gasgoohl hla Naẋ Noḵs Wii Gyat, hots'imo
luunisuut't hlismaxt ts'im aks ii sbi yeet. Neediit ḵa
gyaa baḵhl hla hixhl elẋ.

We-gyet and His Wooden Jaw

We-gyet was wandering along the bank of a river when he came upon a row of young men fishing from the shore using small fish for bait. The small bait fish caught We-gyet's eye.

"What is good food for my brothers of the water is good food for me," We-gyet said to himself, "I will share with my brothers."

Unseen by the fishermen, We-gyet slipped into the water. In a short time every fisherman had had a big strike! In an equally short time every fisherman had lost the fish that struck, and the bait. The fishermen, certain that big fish were at hand, quickly replaced their bait fish and tried again, positive that their food boxes would be full that evening!

We-gyet happily supplied the optimistic fishermen with another round of excitement as he feasted on the new bait.

We-gyet was opening his mouth to begin a third course of bait fish when a fisherman with a fishing fork drove the prongs through We-gyet's open jaw.

"I've got one! I've got one!" shouted the man as he pulled with all his might. "It's the biggest fish I've ever caught! It's too big, too heavy for me to land alone. Will some of you come and pull with me?" His friends willingly rushed to help him and together they tugged and heaved to land the giant fish.

At the other end of the fishing fork We-gyet was in a frenzy. He knew that he would be killed as a thief and trespasser if he surfaced so he anchored himself by clinging desperately to a huge boulder.

*Medeek** could not have hung on with more strength! But the combined efforts of the fishermen were too much for Big Man and thumb-length by thumb-length he was being drawn towards the surface.

The wish-making words were his only hope. *"Bsaa! Bsaa!* May my jaw break off so that I may not be discovered!"

We-gyet's wish was granted, but at the very same moment the fishermen gave one final, mountain-moving pull.

Swoosh! We-gyet's open jaw sprang from the water like a stone from a sling shot! The fishermen tumbled backwards. The jaw flew off the fork and chomped on the nose of the nearest fisherman then fell to the ground at the stunned man's feet!

If the sun had dropped on them the fishermen could not have been more terrified and surprised. They crept away from the jaw 'fish'....

Was it a warning?
Was it good luck?
Was it bad luck?
Should they throw it back in the water?
Should they take it home?
What *should* they do with it?

Eventually they decided to conceal it in a woven cedar bag and smuggle it back to the village where their elders could advise them.

At home in their village they hesitantly displayed their unusual catch to the wise and elderly leaders. After many hours of deliberation the elders decided not to rush headlong into a course of action which

*Supernatural Grizzly

26

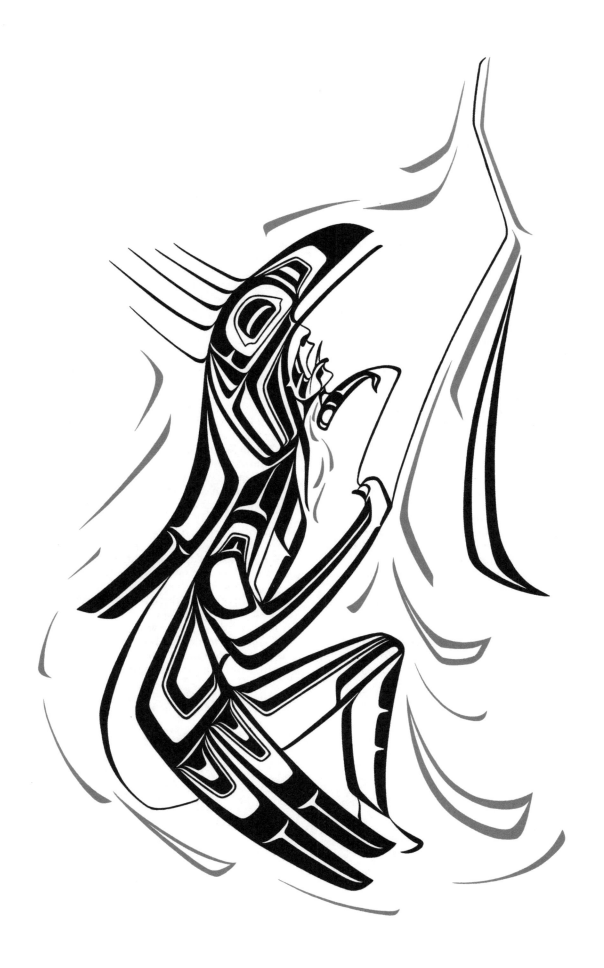

might end in disaster. They suggested that the jaw be lashed to one of the high crossbeams of the house, where all could keep an eye on it, and that they then await developments.

In the meantime We-gyet was having problems. He had made a substitute wooden jaw but it did not fit him properly. He could talk with it, and did, but he could not eat. As much as he relished conversation, particularly his own, it did not fill his stomach. He decided that he must recover his real jaw or starve to death.

He made a plan. Somehow he assembled apparel which gave him the appearance of a wealthy and prominent chief. Then he started off toward the village of those who had fished up his jaw. Close to the village he met a young boy whom he paid to run ahead to the village and make it known that a great and wealthy chief was close at hand.

As a result the village chief greeted We-gyet at the outskirts of the village and "called him in". We-gyet silently made the wish, *"Bsaa, bsaa,* may my jaw be in this man's house." As We-gyet entered his host's house he looked around to see if his wish had been granted and was immensely relieved when he caught sight of his jaw lashed to the house beam.

The village chief instructed the ladies of his household to spread a new food mat for We-gyet and serve the best provisions the house had to offer. We-gyet had some trouble concealing the fact that he could not eat and even greater trouble concealing his longing to devour everything in sight! To cover up he pretended not to be hungry so the courteous host asked his entertainers to perform for We-gyet.

While he was being entertained We-gyet was planning. He believed in making a wide circle when stalking his meat so he said to his host,

"Great Chief, is there a good fishing place close by?"

"Yes, Chief, indeed there is. A very fine fishing hole!" the host proudly asserted. When speaking of the hole he remembered the jaw as We-gyet had anticipated he would. The Chief decided to consult the knowledgeable visitor.

"At the fishing hole of which I speak, youths of our village recently made a most unusual catch. We are not as yet sure how to interpret it. Perhaps, Chief, you have knowledge of such matters. One of our young fishermen caught what appears to be a...human jaw!"

"A human jaw," We-gyet repeated in a tone of complete disbelief. "Surely one cannot net a human jaw in your fine fishing hole. It *must* be something else."

"It resembles in every way a human jaw! Look, there it hangs!" said the host, pointing to the jaw.

We-gyet looked up at the beam as though he had not noticed the jaw until that moment.

"That cannot be a human jaw," he stated in a tone of authority. "Perhaps you had better let me examine the thing carefully."

They took down the jaw and gave it to We-gyet.

We-gyet pretended to handle his own jaw with the greatest reluctance. He warily held it at arm's length, scrutinizing it with the utmost care. After a

moment his face grew very solemn and his eyes filled with dread as one might who heard the Dead moan.

"My dear Brother, it grieves me to tell you of this but your kindness to me has known no bounds and I must repay you by warning and advising you.

"A jaw exactly like this was fished out of the river close by the dwelling of my dearest uncle. Within a day, a terrible Sickness overcame the villagers. Everyone died. There was no one left to cremate the dead. There was no one left to sing the mourning songs. I advise you to depart immediately and take nothing with you lest it be poisoned with the Sickness."

Fear filled the hearts of all who listened. Even the wisest men did not pause to question We-gyet. In great haste the villagers raced down to the water's edge, ripped the woven cedar coverings off their canoes and rudely scrambled for space in them.

We-gyet rushed down to the water too, generously finding seating space for elderly people and unselfishly seeing to the welfare of all his new friends. Nobly he gave up seat after seat to make room for a villager.

"I'll stay behind and warn any who come by," We-gyet promised bigheartedly as the last canoe pulled away from the bank.

As soon as the canoe was out of sight We-gyet tore out the wooden jaw and crammed the real one into his mouth. Then he pranced through the village gobbling food right and left while he made a joyful count of all the good things he had tricked out of the gullible villagers.

For the moment, We-gyet's journeying was at a standstill.

Xp'a'aw's Wii-gyat

Kwihl hahl yeet Wii Gyat lax ts'eehl aks iit w'aw'il yukwhl ixwhl ḵay limx̱sit. Laaxwhl n'ax̱diit. Wilk'y' si waksdy's Wii Gyat ahl hoen ts'im aks gasgoohl hla xwdaxt.

Dimhotẏ gubẏhl wineexhl w'ii t'ax̱ wakx̱wy' ts'im aks dii ya.

Neediit gya'adiit wil yees Wii Gyat ts'im aks ii sim am dulp'xwit iit sa jihl jahlis Wii Gẏathl n'ax̱. Wil a'aẏhl ga i w'it wil w'ii t'ishl hoen an sajihl jahlihl nax̱diit. Iit n'ii maḵdiit w'ii t'aawilt ii w'ats wii tishl

n'ax̱ n'ii t'aadiit' loot, an'bisxwdiit dim sim luumidmitxwhl enḵdiit jihla yuxwsa.

Kiy'hl ho ḵaḵs Wii Gyat dimt sa hats'ihl n'ax̱ sim sax̱ahl k'yul i w'it deex̱ixw't sim hakwihlit xp'a'aws Wii Gyat ts'aagukwasxwhl muk'wid ii sim dal'gahlx̱wt m'ukw n'iẏ, m'uks n'iẏ, diiya. Gaal' w'iitishl hoen t'un ndim am dikyultxwt gala sim hlimo'oy' dii ya, ii wilk'ii habadiihl hlagats'uut' iit sbi'damgandiithl m'ukwdiit.

Goya kiyhl wil'a dax̱t'ogasxw Wii Gyat ii ap'

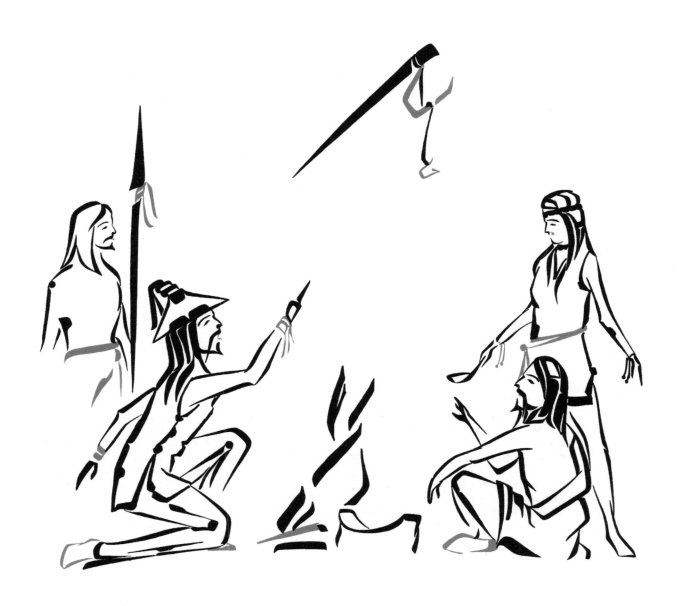

sbi'yukwt, koo luu dam'xswthl wat's w'ii t'isithl
lo'op ii ap' xsit'ḵahukwsxwt.

Sim am kiyhl wil'aay't dim het ii wilky boxdy
bisaa ji m'atxwhl xpa'awy's diiyahl boxt. Ii wilkii
nidiihl wilt xsi tḵahukwsxwhl xp'a'awt ah hakwhl.
Wihl ap wil da'awihldiihl ts'iiba lo'op'iihl wil xsi
goshl' xp'aawis Wii Gyat ii de'et ahl ase'ehl k'yulhl
iẇit.

Jaan' t'uugwant'xwhl hloxs jii neejidii
ts'aagal'iiguxwsxwhl iẇit. Hats'im ts'inxs huuda wil
sk'ihl xp'a'aw, ii sim gwil'daxwdiit ahl wila jabihl
mukwdiit gwihl wa wil magoontxw, dahiit'a.

Yugumahl sagawsat, yugumahl hataḵwhl dim di
aat'ixsit. Yugumahl am jidip' guuxws loḵan
hal'adin't ts'im aks dihiida. Nee diiyahl hlaḵat-
s'uudiit jidip' guxws diyeet wil waṅhl ẇii
gaxho'osxw't iit luu maḵdiit ts'im hlgwa'al't.

Hla guuxws bakxwdiit goohl ts'ap, iit ts'ixs
guudiit xwp'a'aw iit laagal'hl ga dagookxwdiit, ii
sim k'yaa sit'il gat'getxwsdiit, neegi saxwhl goodiit
wil up'ji han'wilt'xw ts'apdiit ii sagagootxwdiit, dim
t'ḵal dakhldm lax gan'ilp' dimiidip lil'xt. Gya'am
dim gay wilt.

Iit wilk'y jap'dy's Wii Gyat t'ḵal jabans' ḵets, iit
hooxwt, ii needi da'aḵhlxwt dim ge'n loot, ii ap'
needit da'akhlx dim yookxwt. Sim wan'txwhl goots
Wii Gyat wil yukw dim xhlaḵelxt ii sigootxw dimt
wila guuxws da'aḵhl xpa'awt, hlagook dim n'u'wt.

Need sin'akwst wilky't jipjapdiihl haxhooyasxw
dim gwiis simoogit ii ẇudn' yeet goohl ts'ap, an't
mukwhl xp'a'awt, hagwin yukwt diswilt dalt'xwhl
hlgut'ihlxw iit yuuhlimxt dim het guuxws yin goohl
ts'abis, ii hen' dim gwin wilaaxdn' wil aat'ixs ẇii
simoogit.

Ii wilk'y guuxs hats'altxwdẏhl hlgut'ihlxw sa ii
n'ithl het hlaa guuxws w'itxw't't iit luudaltxw
simoogitxwhl ts'ap, nit ii hi yees Wii Gyat ii boxt
bisaa, ja luu w'it'xwẏ goohl wil luu n'ii huksxwhl
xp'aawẏ, ii nithl wilt.

Ii sim needi simhetxwst jiligi ap nithl xp'a'awt ji
gya'at lax gan'il'p. Hehl ap' moot'xwidẏhy het.

Iit aw's guuhl simoogit sim sii wil'thl sgan'a ii het
ahl w'at'uxwst aws dokhl wil sim k'ya amhl wineex.
Neediit daakhlxws Wii Gyat dim ge'n't, ii xwdaxt,

has'aḵt dimt sagayt hloojaxt tḵanitxws wineex ii ap'
aḵhl t wil'aagwit ii needi kwihl his' xwdak'st ii hehl
simoogit ahl t'ḵal wixwil'iinxwt lipligi agwihl wisim'
loot.

Iit t'ilxhoot'xwis Wii Gyat dim wila het gandim
wila wilt. Wii simoogit dii ya, neehl hagwin dul'pxw
ama an'ixw'a diiya. Yagayt gwildim wilaay's Wii
Gyat dim hehl dilimxxw ganeehl wila gidaxt.
Simk'yaa ama an ixw hlaḵaphl ts'ap diiyahl
simoogit, goohl ama anixw anee'ist, mukxwihl
ḵ'aylimxsithl xp'a'aw loot diyahl simoogit as Wii
Gyat. Ii sim yal'ims ts'aa gyuksxws Wii Gyat Xpa'aw
diiya, neendy' simhedn't dii yat Wii Gyat neediit
baalgi mukxwhl ligit naa xp'a'aw goohl ts'im
t'in'sim diiyat Wii Gyat ii hehl simoogit a's Wii
Gyat. Lip' gya'awil n'ii huksxwt lax gan'ilp's diiyahl
simoogit.

T'ip n'dee'e looẏ dii yat Wii Gyat iit guud iit.
W'ats' suuẏ w'dn yugwid hats'im ligigw'ant'xwhl
ts'a't, ii yukxwhl sik'ihl ap'hetxwst. Wak'xw diiya
get'xwhl goodẏ nit gan win'dim mahl't loosim'.
M'uk'gwihl ts'ap's dip' biibẏ wila jap'id tunhl
xp'a'aw ii sim luu tḵal' goodiit sim sida dak'wsda,
gasgoohl hat'aḵwhl has'iipxw ant' w'adiit.

Neediit naa ji man't dim ant' yeedihl limx ooẏ
loodit. N'it dim ganeeẏ loosim am dim hats'im ligi
huudsim dim xhlaa t'ahl disim t'xa n'itxwsh
t'oost'disim hli gookjit daawihlxwhl hasiipxw.

Hats'im kwihl hugwiltxwhl gyat, ts'aa w'ats
guxwxhoo'osxw't'ii needi am ligi al'algyaxdiit.
Hats'im gol'da lax ts'eehl aks iit hats'im ligit loḵ'an
deexsxw'diithl m'al, gas wil k'wihl baxs Wii Gyat
hlimoomsit hats'im hi loḵan t'istisithl gyat gasgoohl
hla saxwhl goot't.

Dim gina kwihl wil niy' neegyaa jit' gabidn'hl ligi
kyuhl gyat, si am'hl yukwhl het di saa goodahl m'al
sim gawil a hayk'wshl gyat.

Ii baxyee yees Wii Gyat iit suuẏ saa guudihl
lip'xp-aaw't lax ganil'p' iit suuy' sil'dn'hl xp'aawm
gan't, iit luu t'ishl lip xp'aaw't iit hats'im
duux'ḵap'hl ts'ap ii yookxwt ahl wineex.

N'it gan'wihl neem' dim dii simhet'xwsin ahl
het' dim nax niy'n'.

We-gyet in the House of Seal

We-gyet travelled on.

He came to the house of Seal.

Seal invited We-gyet in for something to eat and prepared a big tray of dried fish.

Then Seal went over to the hot fire and held his hands over the flames for a short time. He went back to the fish and again held out his hands. From the tips of Seal's fingers flowed delicious seal oil, enough for all the fish.

In the true Indian way We-gyet wanted to give a return gift of food, a gift as good or better than Seal's. The Big Man therefore called Seal in and prepared a tray of fine dried fish, a tray larger than the tray in Seal's house.

When the tray was ready We-gyet went to the fire and held his hands as Seal had done. To make doubly sure that his food gift matched Seal's, We-gyet held his hands over the fire for a long time, in fact, until they were nearly burned and had become black with soot. Then he shuffled over to the tray of fish and held his fingers out duplicating every motion Seal had made.

No oil came from We-gyet's scorched fingers. Not a drop.

All We-gyet got for his effort was a pair of parched and blackened hands.

Today, as we watch the crows and ravens waddle their stained and blackened Feet we are reminded of We-gyet's failure.

Wii-gyat Goohl Ts'im Wilphl "El x̱"

Si'amhl yees Wii Gyat iit ẁahl wil het'xwhl wil'p'hl El'x̱ iit tsil'm uu ẁihl El'x̱t Wii Gyat ii ẁo'ot'xwt loot', ii yu kwihl El'x̱ gwil'dim goodṅ dim gubis Wii Gyat.

Aẁs guudiit'hl lu haṅksa ts'akx wil luu d'ox̱hl mihl'orh hoen, hats'im xsigal'gol' hla yahlx̱s Wii Gyat, iit' g̓ya'ahl El'x̱sahl wil sim xẁdaxs Wii Gyat ii sim hagwil k'wihl wilt.

II ṅiiḵaṅ het'xwhl El'x̱ lax̱ts'eehl lakw ṅii silŝ'il'kwihl an'ont' lax lakw, iiguuxws yeet wil luu dox̱hl hoen ts'im ts'akx iixsigal'gol' tilà'El'x̱ ahl gats'uwinil't ii sidajaxwt ahl hoen ts'im ts'akx.

II gas yookx̱ws Wii Gyat.

II gasggoohl hla harhiyaas Wii Gyat ii luuṅi'guuṅasxwt. Nithl dii wilà loohl Gitxsan goyadii yoogandiithl naahl wo'ot'xwit loot'.

II has'aḵs Wii Gyat dim k̓yaa x̱st'aa dim hàb̓y wo'ot'xwt, iit aẁs guus Wii Gyat k'yaa ẁiila'y̓thl ts'akx wil luu dox̱hl sim k̓yaa arharha hoen, ii diit luu hooxwhl wihl El'x̱ sa, uxẁs dax̱ dok̓'ithl aṅoṅt wil mihl lakw, ii hlaasim l'iml'arhkhl anoṅt, hats,im' jihhts'atlxw iit guuxws diiyeet wil luu doxhl hoen ii yuugwihl bisxwt dim xsigal'gol' t'il'x. Ahl' gats'uwinil't't needi xsigal'gol'hl t'ilx' loot.

N'eediit' da'aḵxws Wii Gyat dimt luu hog̓yax̱hl wila wilhl El'x̱ ii ap' goodahl dii ẁaa'ys Wii Gyat ahl dii sik̓ihl wil'txw. Sim sa jihlts'atl'xw aṅoṅt, ii jihljoohlt.

Nit' gaṅwihl needi arhjit sik'ihl luu hooy̓hl gyat wihl sil'gyat.

M'ahl'a k'yul't' lo'orh wil luu skil'h ay̓aẁilt. Tŝal'igi ṅday̓hl g̓àsgoohl dim baḵxwrh ii ap' needim diigiṅarhtxwt. Loorh y̓agayt t'ḵal' sgyadiit gan' wil'aakil'st skit all hl'aga ts'uuhl gyat.

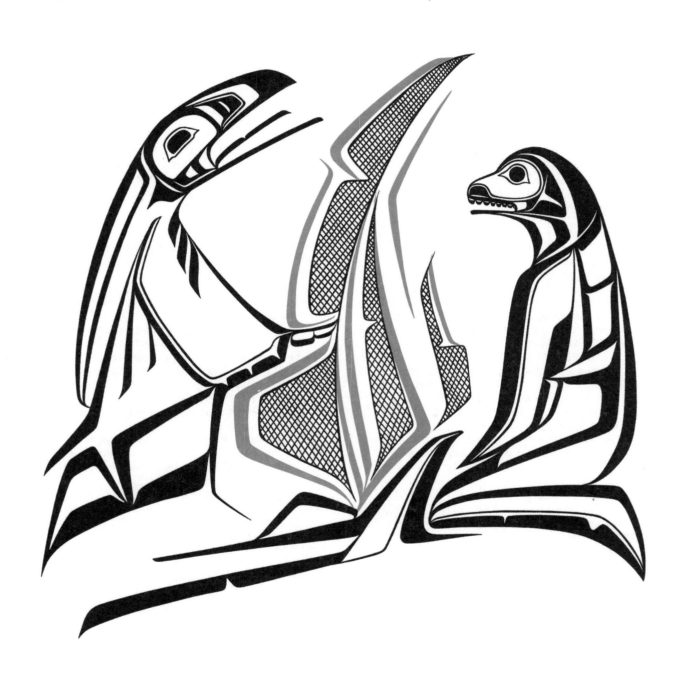

We-gyet and His Wooden Slave

Now We-gyet knew that he had worn out his welcome with those who knew him. He set out on a journey to find new villagers.

Coming to the bottom of a hill he saw a fine big village at the top.

"A-ha," he thought, "This will be my first stop. I must make an impressive entrance."

He decided to bedeck himself as a great chief, complete with slave.

First he gathered odd bits of wood and moss and hastily fashioned a wooden slave. Then using all of his ingenuity he created an impressive costume for himself. As a final touch he gathered fish bones, cedar tassels and bits of moss. He carefully fitted these odd bits into an awe-inspiring chief's headdress.

We-gyet was pleased with himself and approached the wooden slave to complete his invention. Leaning over the wooden man he breathed on him, one, two, three, four times, saying "You will walk, you will talk, you will obey me."

This was the first slave We-gyet had ever contrived and he blew great breaths to emphasize his words.

"Walk!" We-gyet commanded.

The slave walked.

"Speak!" We-gyet ordered.

The slave spoke.

We-gyet did a little dance of pleasure and anticipation.

Now he must teach his slave obedience. Strutting before the slave he began his instruction.

"I am a great chief. I wear the robes and headdress of a great chief. I walk and speak with the manners of a great chief!" and he walked up and down strutting and preening before the watchful slave.

"Now, slave," We-gyet said, "What do you see?"

The slave studied him.

"I see a big man dressed in moss and cedar with fish bones on his head," he replied.

We-gyet was astonished.

"That is not what I told you!" he yelled. "I am a great chief. I wear the robes and headdress to prove it! Now say what I wish you to say. At once!"

But We-gyet had erred in his hasty construction of the slave. In his desire for obedience he had blown his breath too hard into the wooden man. Part of We-gyet's nature had slipped in with the breath and he now faced a counterpart of himself.

Once again the disobedient slave chanted the words, "I see a big man dressed in moss and cedar with fish bones on his head."

Over and over We-gyet shouted his instructions only to confront the cold eye and calm voice of the slave who repeated what he beheld exactly as he saw it.

We-gyet was furious. Rushing at the slave he bashed it about until it fell apart at his feet.

Then hurrying to the forest he found different wood and moss. This time he took great care as he assembled a new slave. Then using his supernatural powers he bent over his creation and breathed lightly, one, two, three, four, times on it; trying

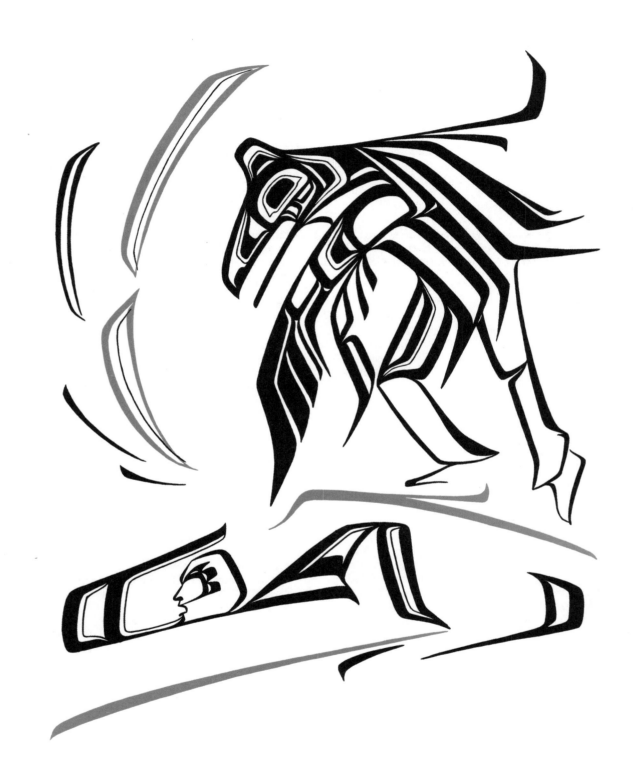

desperately not to allow any part of himself to escape with his breaths as he instructed the slave.

"Walk," he commanded.

The slave walked.

"Speak," he ordered.

The slave spoke.

"I am a great chief," We-gyet began, eyeing the slave as he strutted up and down. "I walk and speak with the manners of a great chief. I wear the robes and headdress of a great chief."

The slave watched him.

"Now, slave, what do you see?"

Lowering his eyes, the slave replied: "I see a great chief dressed in fine robes wearing a handsome headdress."

We-gyet was delighted. Now he could commence his grand entrance into the new village.

"Slave," he said, "I command you to enter this village. Go to the center of the houses and sit down. Wait until the people come, then rise and make this proclamation in a loud voice, 'A great chief is about to enter your village. He walks on the trail below. I caution you to welcome him appropriately!' "

All this the slave did.

The people flew about preparing a magnificent feast.

At last, satisfied with his appearance, We-gyet stalked out of the trees and climbed the trail to the village.

The villagers stood in awe at the sight of the big man draped in the robes of a mighty chief. They led We-gyet to the feast. Bending low one spoke quietly to the slave, "What does your master prefer to eat?"

Now this slave, too, was the mischievous creation of a wily and devious creator. Like We-gyet he found it difficult to speak the truth.

"Oh," he said with great humility, "My master is a simple man. He will accept only that which is left after everyone else has had their fill."

The host chief was so impressed by this request that he rose and proclaimed We-gyet's virtues to all of his people.

The astounded We-gyet could scarcely believe his ears! He turned to question his wooden slave but the slave sat with his eyes respectfully lowered to the ground and the frantic We-gyet could not alter the proclamation in any way.

So the food passed by him, bowls of berries, steaming boiled meat, succulent baked salmon, beautiful wild rice, mounds of beaten berries — none were offered to the visiting Chief. Only the mischievous slave was plied with the bountiful array. The people marvelled at his capacity, he seemed to be a bottomless pit!

Poor We-gyet, sweltering under his finery, faint with hunger and trembling with anger at the trickery of his wooden creation sat hopelessly trapped through the long meal.

As each heaping dish passed by him, he would reach over and scratch at the wooden back of his tormentor. First in anger, then in pleading tones he begged for a morsel before it was all gone. The wooden slave paid no attention and ate on. As the hours passed We-gyet's frantic scratches caused a pile of tiny shavings to pile up behind the slave who was far too busy to notice.

At last there was nothing left for the host chief to offer, nothing left for We-gyet.

The people watched in admiration and respect as We-gyet and his slave rose with dignity and slowly departed from the village.

As soon as they were decently screened from their hosts, We-gyet flung off his fake robes. With loud and descriptive oaths he attacked the wooden slave.

Boxing it about, he kicked it soundly until it burst open spilling the conglomeration of the feast over the clean moss.

Chief's crown askew, tattered tassels in every direction, the ravenous We-gyet dove in with hands and feet to gobble the unsavoury array.

No proud chief now, he scrambled about eating every morsel.

Then he ruefully went on his way alone.

Meanwhile the villagers had discovered the heap of wood shavings. They suspected a ruse and set off in hot pursuit of their charming guest.

When they found the remains of the wooden slave and We-gyet's robes, they paused.

Now they knew they had entertained We-gyet, the Big Man.

Tḵalwilimxum Gans Wii-gyat

Iit aw's guuhl simoogit sim sii sgana iit ba'hlit gaseexws Wii Gyat gwin gyaat'it' wilt hlo'ot'it', ii het' ahl luu hanaḵ'hl wilp' sim aw's ga'l' hluuwilsim k'ya amhl wineex dii ya.

Ii sim hagwin t'aahl sigyadim gan's Wii Gyat goohl ast'o'oxst, gasgoohl hla xsl'aẋha'hl simoogitt.

Am gal'xsi yuuwihl al'gyaẋ t'ḵalwilimxws Wii Gyat gasgoohla ẁii hlgu'wilk'shlẋwt neediit naa dim ant luu dal'ḵhl ts'a'at.

Iit aws guuhl hanaḵhl stikyeekwhl simoogithl ẁii gwal'gwa ya'a iit gidaẋhl tḵal'wil'imxws Wii Gyat ii het, neet gup'hl hlgu'wilk'shl'xw gwalgwa hoena diiya. Nee diiyahl tḵal'wilimxw sim amts'in sgants'dis Wii Gyat t'ḵalwilimxwt.

Hots'imo aws guudithl smaẏa matx iit hotsimo gidaẋt, neet gyp'da dii ya, hots'imo al'gyaẋ t'ḵal'wilimxws Wii Gyat nee dii ya. Ii sim daaẋgyat sganjis Wii Gyat tḵalwilimxwt, ii het gubit mii ya'an' dii ya si amhl yukwhl het itt guuxws dida awihl hanaḵihl smaẏa matx.

Ii sim wanhl ts'a'as Wii Gyat yukwt wits'xwhl haanaanaḵhl sim ma'ay', hats'im hloḵ'aasxwt Wii

Gyat ahl hla yahlẋt iit luu t'week'sinhl hanaanaḵhl sim t'ilx loot, ii hots'imo het, neet gup'hl hlguuwilk'shl'xw hlayadim ma'ay'a dii ya ii sim daaẋgyat sganjis Wii Gyat tḵalwilimxwt, mooji j ap't'ḵakwadixsxwt, gubit mii ya'an'dii yat Wii Gyat. Nee, neediit gup't dii yahl t'ḵal'wilimxwt iit hots'imo guuxws dida'awihl hanaḵhl ma'ay.

Goya kiẏhl sim axst'adhl wineex k'woo aws guudiit loot, ii ap' am k'ik'iẏhl hehl tḵalwilimxwt, neediit gup't diiya. Needi gwihl wa joo m'an't dim hab'y wo'ot'xwsdiit. Sim k'yaa al'aẋ ii ap'neediit gwin gya'adit, ii am sa amhl het'xwt, ii hagwil'ii yeet hla xsaxwt, xsi stilit t'ḵal'wilimxwt; lip japt ahl sigyadim gant.

Hlaa luuk'witk'wootxwda hla ḵ'aphl ts'ap ii sim k'yaa siipxw hla al'aẋt gasgoohl hla xwdaxt. Ii sim midmaatxwhl het ahl sigyadim gant. Lip ligiwila daẋ doẋhl hat'agam al'gyaẋt, sim xwhlii goodn't ẁii t'ḵal'wilimxum gyadim gant.

Nit' ganwihl needim dii yaamgasxwhl gyat ahl wila didilst. Neem diim dii sityeewihl wila gyoo n'.

We-gyet and the Swans

We-gyet walked on until he came to the house of a great chief. The courtly chief invited We-gyet in and fed him royally.

We-gyet noticed the many swans skins hanging at the back of the house. "How do you ever catch so many of these big birds?" We-gyet asked.

"Look to the other wall," replied the chief. "You will see a skin and feathers. When I need a bird I put on that swan disguise and swim out among the flock. I take my cedar rope and tie together the legs of the birds I select. Then I pull them to the shore."

"Let me try," begged We-gyet already savouring the flavour of the big, fat swans.

"Very well," said the chief, "But remember, you tie the legs of only two or three swans. Do not cripple the flight of more than you need. That is the rule I place on you."

Eagerly We-gyet agreed. He put on the disguise and slipped into the water. When he reached the swans his short memory and greedy nature got the better of him. He thrashed wildly about tying legs here and there, including his own, into one tangled mess.

The startled swans rose in a body carrying the helpless We-gyet with them high into the air and away. The swans ignored his shouts of anger, his roars for instant obedience, his pleas for mercy. On and on they flew until, snap, the rope broke.

We-gyet dropped. Down, and down, and down. So fast that he overtook the Wind. He was rapidly nearing the earth. Terror-stricken he wondered, "Where will I land? Where will I land? If I land in soil I'll be buried alive." He made a fervent wish. "Bsaa!" (That is the word with which our ancient people began a wish that was to be successful) "May I land on a flat rock!"

And land on a flat rock he did! And with such force that he was driven deep into the surface of the stone. Imprisoned in his own print We-gyet bellowed for someone to come to free him.

The animals came by attracted by the noise and curious to learn the cause of the bellowing. They tried to help. Even the little squirrel heaved with all his might. But We-gyet was fixed firmly in the rock and one by one they gave up and departed leaving the noisy fellow to arrange his own escape.

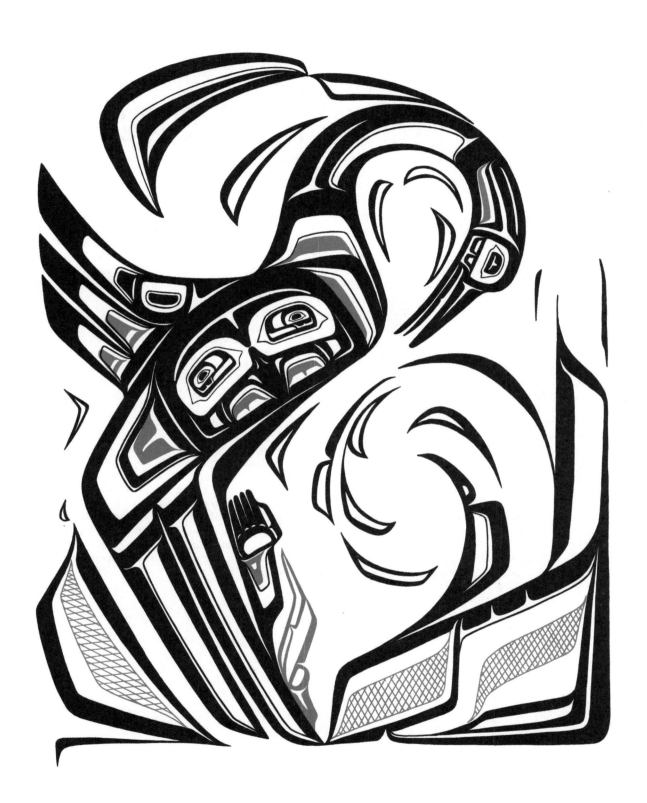

Wii-gyat ganhl dil' googa

Ii yees Wii Gyat waayt wil hetxwhl wil'p simoogit, iit ts'imwil uu'ehl simoogit Wii Gyat ii wo'otxwt loot. Sim hogyagam ts'eeint'.

Iit gya'as Wii Gyat wil lisxw hla gat tkahl dilgooga goohl ḵal'aȧ'nhl wil'phl simoogit sa ii jabaxhl goot't, n'dahl ma wil'a w'atdihl hla gattḵahl dilgoogats' a helt't, ii hehl simoogit as Wii Gyat gya'ahl an st'o'ohl haahl'xans mii gya'a wil niiyukwsxw lila tkahl dilgooga loot.

Nda wil hasagay ahl ts'uuts' nii yo luuhlo'otxw hlatḵahl dil'goog niiyo sagayt ts'iip'xst hlaga sise'ehl dilgooga niiyo sagam digyoot, am jn dii baḵt da diiyat Wii Gyat, hats'im yagayt gwildim bagat smaya dilgooga. Iit anooḵhl simoogit hes Wii Gyat. II ap' tun dim he'ẏ lun', needimdii ḡal n'im midastn am ligi t'ipxaat dim an'win, nit'ndim yuuhlimgan tun.

II ee'asxws Wii Gyat iit wilḵy nii magatdi gwiis dilgoogaat' ii t'aḵst hlaxwhl aks ii.hlaat uxws w'ahl hlahlaxw wil kwihl loohl dilgoogasa iit takxhl hehl ee'asxwt. Gasgoohl hla luu sḵonxwhl goot't ii ṅim midasit, hats'im gabuxwihl aks wil kwihl gyoos Wii Gyat, sim sida ts'iip'xst'diithl tḵaa nitxws hlagas sise'ehl dilgoogasa, iit hotẏ w'aṡ tḵal' tšiipxwhl lip se'et.

Siiamhl yukxwihl wilt di sagayt lii p'aykwt, dilgooga sa, ii haldim tḵa hukwsxws Wii Gyat. Ii sim dalhl ẇii ayawaatxwt, hats'im wil'aat lax t'ax, gasgoohl hla ẇii am'mes Wii Gyat. Sim aḵhl wildiit hooxwhl dilgoogo wil kwihl sik'ihl al'axws Wii Gyat. Hats'im gay m'indigipaykw diit ts'im lax ha. Hlaatgya'as Wii Gyat gan'akw m'inw'aẏt ii sim laa hetxwhl goot't. Gas hisgwin ḵe'etxwst, dil'goo-ga dil'goo-ga...oo neehl gats'im muxwsima, k'wooga sikihl gipaykwst Wii Gyat. Gas goohl hlaa akhlaa wilt.

Sii amhl yukxwihl wilt d't'xwhla'al'st hla de'ehl se'et, sim luḵwil xpts'axwt Wii Gyat n'da dimwil gay al'ba deexdiẏa diyat Wii Gyat neegi amji deexdi lax yip dim n'iiḵan nw'at lax o'ẏ ii ḵo'omgasxwt. Bisaa j' deexdi lax n'iit'ḵa yahlagam lo'op diyahl bo'xs Wii Gyat. Hii yukwihl het di deext. Luuwilt'xw hla ḵoomgasxws Wii Gyat, ṅii deext lax lo'op, gasgoohl hla daxgat wil de'et hatsim hakwaxwihl lo'op.

II luu adisxwt ii sim dal' wii am'es Wii Gyat gwin hlimoot'xwt iit naxnihl tḵa nit'xwshl yajasxw ayawaatxws Wii Gyat ii hagwin ataatixsdiit, iit sikihl hlimootdiit iit gosdiit jit xsida'aḵwdiit Wii Gyat, ḡal, sip'xw wil luu tḵal hit't, gosasxw tḵanitxws yajasxw ts'a tšinhlikẏ baḵxwt iisuuẇy gigk'yuldiit, xwhla maḵdiit Wii Gyat.

Am dim lip guuxws dimootxwst dihiitda, ii saksdiit.

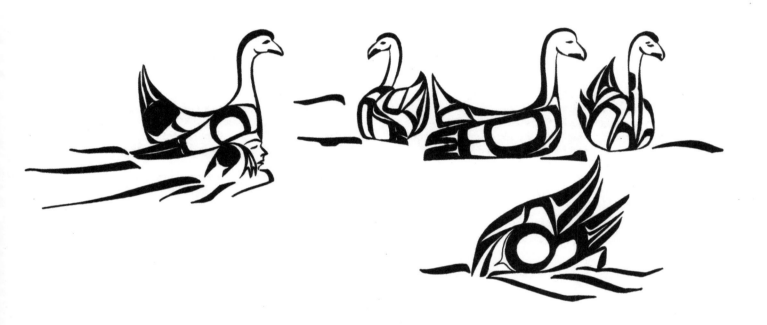

We-gyet and Lynx

We-gyet was giving up all hope of escaping from the rock when Lynx, who was always curious, came along. We-gyet knew that Lynx owned a tongue like a rasp. The Big Man decided to bribe the creature to use that rasp-like tongue to free him from the rocky trap.

"Help me, Great Lynx," he begged. "I will reward you with whatever gift you choose."

Lynx could see that if he succeeded in freeing We-gyet it would happen only after hours and hours of tedious work. Therefore Lynx decided to ask for a payment that We-gyet might not want to give.

"I will try to set you free if you will give me the longest hairs on your body but not those of your head," said Lynx.

We-gyet hesitated. Freedom, however painful, was essential. We-gyet agreed to Lynx's price.

Patient Lynx began to lick the rock with his rough tongue. He worked day after day. Finally one of We-gyet's legs was free. Then the other leg. Then an arm. Then the other arm. Much, much later We-gyet's whole body could move out of the rock. Only his head was anchored. At last Lynx loosened it and We-gyet was free to travel again.

The delighted We-gyet kept his promise. He pulled his body hairs and stuck them jauntily on the ears of Lynx.

To this day lynx walks with the hair standing out on his ears, a payment of gratitude from the Big Man of long ago.

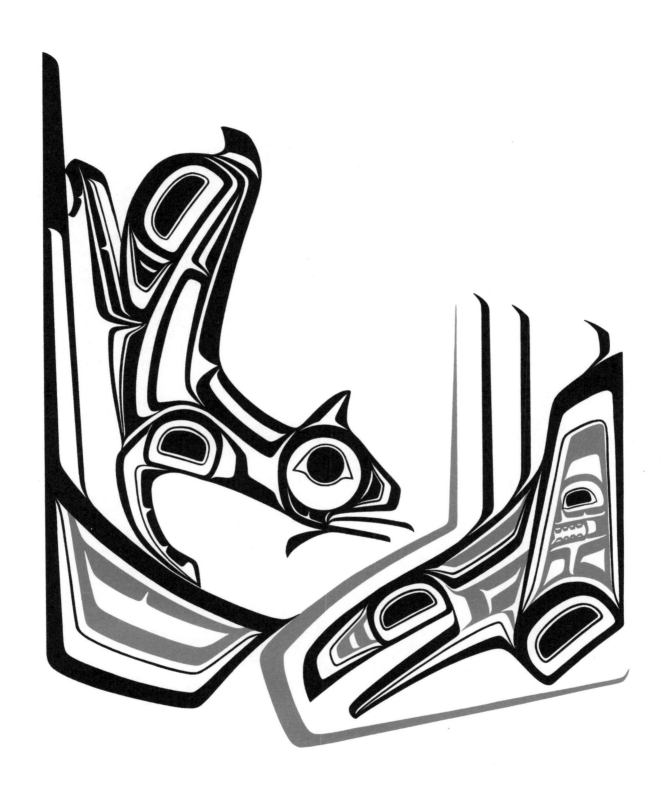

Wii-gyat Ganhl Weex

Guu gwil n'u'uhl Weex, nda wilt gya'ahl ligi asgithl witl ii sim k'yaa gwil nu'ut.

Hla'ap aḵhl wis Wii Gyat gasgoohl hla'ap wil luu de'et ts'im t'aa yahlagam lo'op ii xsihl hlgux-w'sxwit, ḵ'am xsahl moosim se'et da'aḵxwit hlin hlandit n'it anwihl sim aṅgwin u'uhl Weex wil hlin hlantxw ẇiitaẋ moos Wii Gyat.

Wil'aa'ys Wii Gyat wil seegal hla dilẋhl Weex, ii nit wil sim hisgwin ḵe'etxws't gal'a hlim hooy' diiy'a. Ligi agwihl wahl hasa'gan dimiin ap' xhlgo'on loot.

Wilaaẏhl Weex tun wil sim k'ya n'akw dim yuk-wt' dim t'gas xsi da'akwxs Wii Gyat. Nit wil hehl Weex as Wii Gyat han'iꞮ goodiihl needim diim da'aḵxwhl midim xhlgo'oẏ dii ya, ii hots'imo ee'asxws Wii Gyat dim ap xhlgooẏ n'iin' diiya. Nit ganeehl Weex as Wii Gyat. Dim xhlgo'on niy' ahl hla laya m'ins nats'iits'n, ii ee'asxws Wii gayt. Ii wilkii sit'a'amahl Weex tseegithl lo'op' nakxwhl yukwt iit xsidaaḵxwhl st'aa ons Wii Gyat, hots'im xsida'aḵxwt hla sto'ot, goya se'et xsits'eegat, goya hlasto'ot, yuk'wyhl wilt ahl w'ii sagii di t'ḵaax-sits'eeḵdit tkam'os Wii Gyat ganhl t'imgest. Yuk-whl wilt da lip gyat nit ii haldim aḵxwt, ii hots'imo kwihl yeet.

Nit ganwihl n'ii litxwhl t'uuts'xwa laẋ laẋ muxwhl Weex laẋ sa tun, xhlga'ems Wii Gyat.

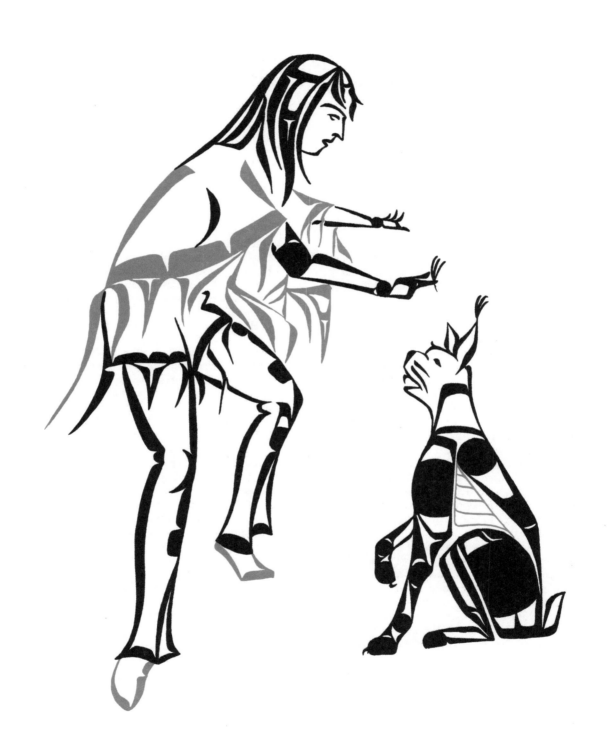

We-gyet and Fire

We-gyet journeyed on. He heard of a chief who had something called 'Fire.' At that time there was no fire in our land. This chief alone possessed fire.

The chief carefully guarded his unique possession. To protect it he surrounded it with a wide band of sharp prongs which stuck out of the ground like the points of double-bladed daggers. Fire burned day and night in the centre of the chief's house. Nobody could get near Fire because his feet would be cut to pieces on the sharp prongs which guarded it.

We-gyet coveted the thing called 'Fire.'

He made a plan.

He prepared the skin and hooves of a deer so that they would fit him exactly.

He sent a messenger to the chief who owned Fire. "Tell the chief that a great dancer is coming to visit. This man can dance, unhurt, over the sharp points that protect Fire."

When the chief repeated the message to his household everyone was curious. Even the knots in the wooden walls knew that the dancer was either *nax nok** or one who turned the truth around. "Call him in," they begged. Which the chief did.

The entire household gathered to witness the exhibition. As no one had ever passed through Fire's sharp protectors, let alone danced among them, the villagers expected to learn that a braggart was reversing the truth.

With a clatter of hooves We-gyet whirled in. He was dressed in deer clothing and wore the deer's hooves on his feet. He pranced and danced across the back of the house and all along the walls, performing leaps and jumps never seen before. His long tail swung behind him (in those days Deer had a tail longer than Cougar's). He sang as he danced.

"Ho there, Dancer!" scoffed the chief's speaker,

*The possessor of Powers Beyond the Human

"You dance very prettily around the edge of the house but you do not approach Fire itself! You claim to be able to dance through the prongs that protect fire! You are a man who talks wind! Make good your boast."

We-gyet changed his song. He took a mighty leap and landed amidst the sharp points where his deer-hoof feet fit comfortably among the sharp prongs. He sang triumphantly, "I dance among the sharp points!" Over and over again he sang the words, "I dance among the sharp points, unhurt, unhurt, UNHURT!"

He repeated the steps he had performed at the edge of Fire's barricade. He danced closer and closer to the fire, his long tail swinging about as he pranced. He reached the very edge of the flames.

The swinging tail caught fire!

We-gyet pretended to be frightened. He rushed out of the tribal house screaming, his tail aflame.

We-gyet had stolen Fire!

We-gyet dashed into the woods, his tail burning all the while. By a punky Stump he paused and, thumping his tail against it, ordered, "Stump, your punky wood will smolder forever in the fire bags of our people!"

A little farther on he paused to swat a big Pine Tree with the still-burning tail, commanding, "Tree, you will burn easily and kindle the fires of our people!"

As he raced nimbly through the woods, We-gyet paused again and again to instruct the trees until Fire shortened his tail to a charred stump that would not burn.

Since that day no deer wears a long tail and all wood burns.

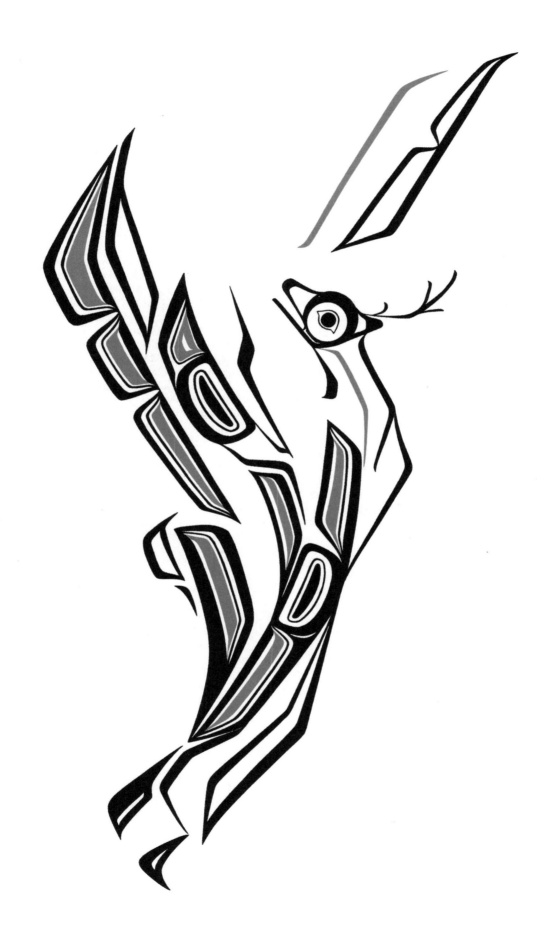

Wii-gyat Ganhl Mihl

Ii kwihl yees Wii Gyat diswilt naẋ nihl wil joḵhl simoogit wat' ahl ''lakw'' needi yagayt mihl agwi tun, laẋ hanijoḵ am'kyul' simoogit wil skihl mihl.

Hla luusilkw wil'phl simoogit wil luumihl lakwsa, gasgoohl hlat siip'int iit l'ihlẋt wil luu jaga mihlt ahl aẋxw ganhl m'isaax, kwit'xwa l'idn't gas siisagat' loot. Ii neediit naa ja'an't gwin dul'bint.

Gasgoohl hla siisaẋt ii ligit naa dim ant sik'ihl gwin yeetxwit loot dimẏ'o xhlii gatgoodhl sise'et.

Hasaḵs Wii Gyat mihl sa iit jap'hl hehl sigoot'xwt dim wila dik'yeekwihl mihl, iit gwildim goot'nhl hla t'ḵahl wan, ganhla neeḵt iit sim lu as, ajaẋhl sise'et, dim hooẏt jihla miil'xwt. Yagay't luuhlẋ'm hejit gimba'at. Hen tun ahl simoogit diiy'a, hlaa at'ixshl k'ya guu miilgwid, da'aḵhlxwt' dimt jaga yuxwihl wil luulitxw gasiisagat ii needim diit han'wilaagwihl sise'et.

Luk'wil luusaanaahl'asxw simoogit ii het ahl tẋaa n'itxws luuwilt ts'im wilp't. T'saa andip'anistdii ahl haahlẋan ii ap' m'inl'uxlukwdiit gasgoohl hla Naẋ Noḵ dim miilgwid yugumahlt gay guuxws luu yal'dinhl al'gyaẋ dihiit'da, ts'imil uu'ehl diyahl simoogit ii nithl wildiit.

T'ẋaa nit'xws hla luu gyadihl ts'im wilp dim al'gal't, wil ha'w'en di naa ja'ant gal'xsiyuxwhl wil luulitxwhl gasiisagat ts'im yip. Ii ha'w'en diit gal'xsa miilxwhl ligit naa si'amli yukwhl hediit di t'ḵan' daawihl aats'ap ii ts'im wil hlo'otxws Wii Gyat. Haxhooẏt neeḵ ganhl gwiis wan.

Hats'im kwihl dagosasxw gaswil miilxwt goohl k'al'a'anhl wilp, goya t'ḵaas miilxw sim lixsgyadim miilxw wila wilt, hats'im kwihl sakwishl hla w'ii n'ak'wa k'uuk'wt yukwihl wilt gaswil guuxws silimkst ahl hi yukwhl wilt.

Iit xsik'yee'aẋ galdim algyaẋwhl simoogit Wii Gyat, ii het. Hogyaẋwihl hla algyaẋn' ba'asxw diiya, am goodihl win kwihl miilxn gaw'l' mihl lakw.

Wilkiit sityeew'is Wii Gyat hehl limxt, ii sim n'akw wil gost, ii luusbagayt dee'et wil luu litxwhl siisagat. Luusbagayt assaajaghlt neeg a wan hla sḵ'ap'dihl wil luusbagayt noonahl gasiisagat.

Iit sim sidaldihl limxt iit sim' aadihl wilt luusbagayt miil'xwhl siisagat. Luusbagayt miilxwẏ sbagayt gasiisagat diiyahl limxt.

Gaswil k'ut'k'u miilxw wil mihl lakw. Yeedẏhl hagwin dul'p'xwt wagayt wil sim hagwin dulpxwt hla laẋ ts'eehl lakw. Hats'im kwihl sakws hla kuukwt hiiyukwhl wil't.

Si'amhl hii yukwhl wilt sim mihl hla kuukwt ii simkya dal'hl yalims awawaat'xwt gasgoohl hla ḵojagat. Hlisxwhl luuwiltxwhl hehl s sigootxwt, mihl hla kuukwt, hats'a'am k'iẏhl gost ii xsi aḵxwt gyal'ḵ iit di ḵyeekwhl mihl, ii baẋt sbagayt gan ii het ahl kiyw'l yeehl gan dim daaẋ mihl n'iin diiya, gaswil baẋt. Dim aẋjiibl'xst n'iin, diiya, dim daaẋ boḵxw ṅiiṅ, yukwhl het ahl ẇii sagi dim aẋmihl ṅiiṅ.

N'akxw wil yeet iit tḵal wadihl tkaa laẋsxwithl gan ii het dimhotẏ diakẋwn dim mihln' diiya.

Sii gyu'un da ẋhlip mihl hla kuukwt ii, dulpxwt ii ts'aḵt nit ganwihl sa tuuts'xw hla kuukwhl wan, saa dulpxwt.

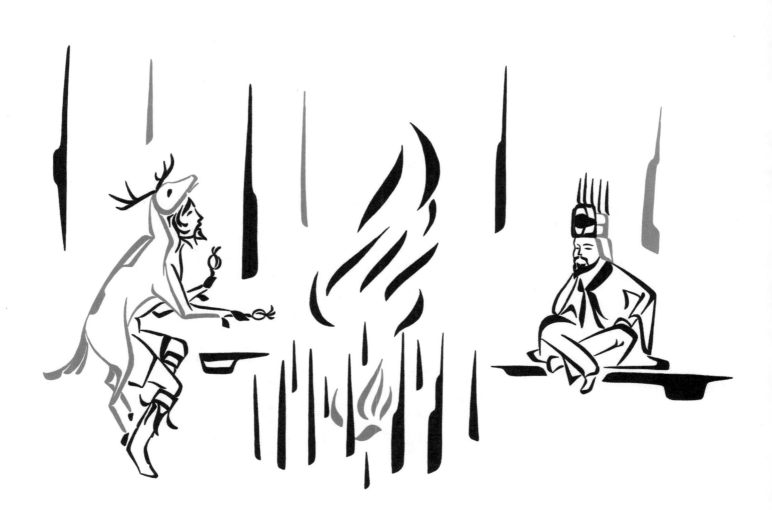

We-gyet and Grizzly Bear

We-gyet travelled on. Hunger gnawed at him without ceasing. As he travelled he thought up a scheme by which he could trick some animal and make a meal of him.

He spied Grizzly Bear lumbering through the forest and he put his scheme to work.

First, We-gyet found bark and wood and fashioned testicles to match his own. These he fastened firmly to himself.

When Grizzly came near We-gyet studied him carefully, as though in wonderment.

"My!" he said, "You travel slowly! It must be difficult to get things done when you move about so *slowly*. Now I have found the secret of great speed and because I pity you, Friend, I will share my knowledge."

"Watch me!" he told Grizzly, "and judge for yourself."

Whipping out a sharp cutting tool We-gyet made a great show of slicing off his testicles (using the wooden ones, of course). With a look of disdain he flung them far away (where Grizzly could not get a close look at their construction). Then with the speed of the wind We-gyet ran.

Grizzly could scarcely see him he ran so fast. In no time We-gyet was back beside Grizzly. "There," he panted, "did you see how fast I ran once I was free from the weight of those things? That is your problem, dear Friend. If you get rid of that bulky, weight you will run with the deer. Here, take my cutting tool, shut yours eyes and quickly cut those handicaps off! You will be free to run at last."

Grizzly hesitated but so impressed was he by We-gyet's dazzling display of speed that he finally grabbed the cutting tool, closed his eyes and bravely sawed off his own testicles. Grizzly began to run but took only one faltering step before he fell and rolled over his back with all four feet wildly pawing the air in pain! He roared so that the forest shook.

We-gyet scrambled up a tree, safely out of reach of the pain-maddened bear.

Grizzly continued to howl deafeningly.

From the safety of the tree We-gyet scornfully called down to the frenzied bear.

"Quiet! You with no testicles, cease that unseemly howling!"

Smug with pride at the success of his scheme We-gyet lolled in the tree and waited for Grizzly to die.

We-gyet decided to cook Grizzly all in one piece. We-gyet was a glutton. He fashioned a large baking pit and rolled the bear into it. There Grizzly cooked for hours while the ravenous We-gyet hopped about the pit snatching small bits off the roasting meat.

When Grizzly was cooked We-gyet cut off the fat and began to eat and eat and eat.

50

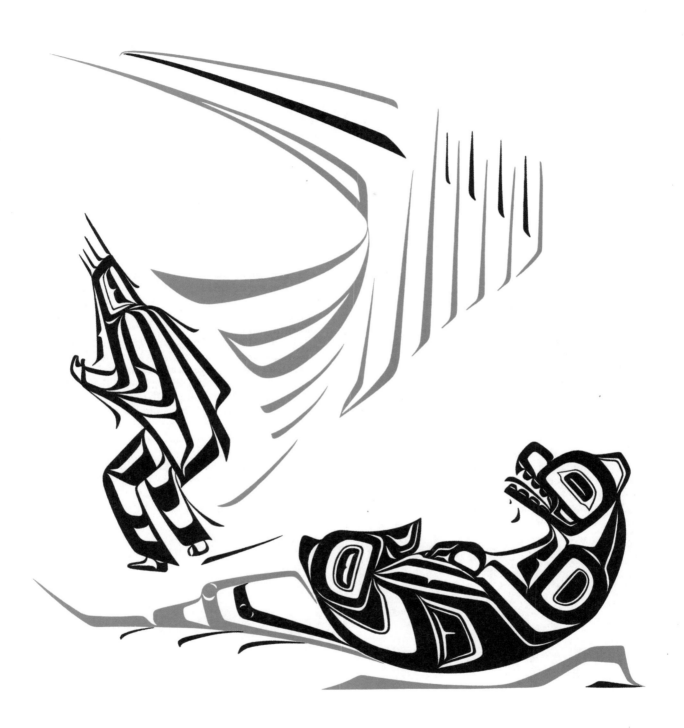

Wïi-gyat Ganhl Likiṅsxw

Il kwihl yees Wii Gyat hats'im luuxstlooxw tse'eẃt gas goohl hla xwdàxt. Hehl ap' luuxhli ḵ'yx̱hadihl hehl ts'im gal'oosid, gas goohl hla xwdaxt.

Sim ẁa'yt hehl sigoot'xwt dim wila sii yaldihl jagwasxw jit sgaẃat, ii wilḵi yukwdi sax̱dox̱ dim anoyat. Aṅi saa gan, ganhl amuluuxhl ẃaẏt, wilk'iit jap't diihl gyal'p dim hoẏt, tḵal jaba anwilt, ii yukwt gildip' sida'deex̱t sbagayt sis'et. Wihl ap hl'ip gyalp'di, iit gyas'as Wii Gyat wil kwihl yeehl lik'in'sxw lax̱ aṁaaxws, hlaa gwin dulp'xwhl lik'insxw sa iit xlii laagals Wii Gyat. Ha'aa dii ẏat Wii Gyat sim kaa ga'gems dim wila kwihl yin, gasgoohl hl sàk hl wila kwihl win.

Aṁ dim miinḵya gol'dṁ dii ẏat Wii Gyat ahl Lik'iṅsxw gi ii ṅithl wildiit. Neehl gwa'amligi sa hetxws Wii Gyat. Wila'aẏ ganwihl jahlẏ dii yat Wii Gyat. Gal' l'ast'indahl gyal'b ẏsa dii ẏa iit guuhl t'uuts'xw iit saa gas ḵ'ots'id, ha'ẁaẏ di, hots'imo miin k'ya gol'dṁ di ẏat Wii Gyat ahl lik'iṅsxw.

Hots'imo gol'da lax̱ aṁaaxws ii x̱st'aas Wii Gyat, ẁo gya'a dii ẏat Wii Gyat saa gas kots'di ganwihl aḵol'ẏ'st. Dim dii saa gàs k'ots'dinhl hla gyal'bn dimii kẏaa aḵol'ṅ dim sil ga bax̱w'n hl kẏaa aḵol'thl wàn, dihiiksis Wii Gyathl lik'in'sxw sa, dim ts'iip'

niin ii wal'ks midṁ saa ḵas ḵotsid dim mi di aḵol'n.

Iit guuhl Lik'iṅsxw gihl t'uuts'xw iit dax̱doḵhl hla gyal'bt ii ts'iip't sim gwal'im lax̱minhethl good't gasgoohl hlax̱ x̱p'its'ax̱wt t'asxwa diyat, Wii Gyat. Sim aḵhl nu'wil' dii hooxwt ja al'isxwn ahl bax̱.

Il ap gasgoohl hla nookt ahl ga aḵol'x̱s Wii Gyat. Sim sa gasḵots'dithl hla gyalb't ii bax̱t, amhlabuu wilt gis t'ahl ehl sise'et ii tḵa kwadixswt, hasbaa hiilitxw sise'et iit gap'gabhl gal'bits', gasgoohl hla siipxwhl bagat.

Hats'im hlinhlantxwhl gangan gàsgoohl hla dal'hl aẏyawaat'xwhl Lik'iṅsxw sa. M'in k'eeḵxws Wii Gyat lax̱ gan ii gaysim tkal'yeehl aẏawaatxwhl lik'iṅsxw sa. N'it' wil goẏa hes Wii Gyat gyaaa wahl ts'eekxw at'ii gyalb'bit hleets'a diyat, Wii Gyat.

Ii sim neegit naa as nit gasgoohl hla amhl sigootxwt ii, gibee'esxwt dim n'u'uhl smaxsa, ii wil'kii yukwdiit japd dim aṅsiaṅgwad. Dim tḵaa uudẏ diyahl sagoot'xwt.

Iit luu woḵhl yip iit tḵaa loḵaa laal'iḷbnhl smax sa loot ii hla yukwhl aṅkwist ii k'witxoo gos Wii Gyat gas wil saa t'x̱ togahl hla hixhl smax sa iit gupt ii yookxwt ii yookxwt.

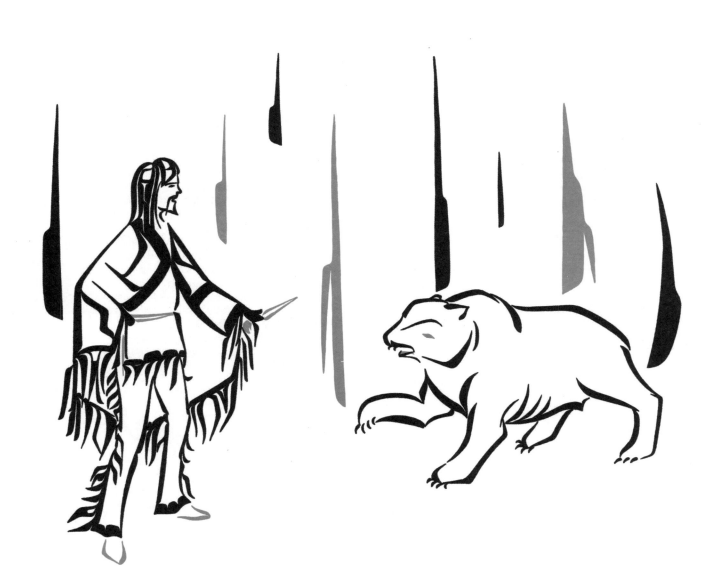

We-gyet and Stump

At last the hollow place in We-gyet's belly was round and firm. He was full of bear meat, high spirits and over-confidence. Lacking a human companion to whom he could display superiority he chose to badger Stump, who was nearby.

Stump, deep, wide and solid with great branching roots stood on a little rise a stone's throw from We-gyet.

We-gyet lolled on the grass and with his mouth full of bear meat needled Stump.

"*Hlimts haats!* *Here, have some," We-gyet mumbled, teasingly holding out a delicious chunk of fat. Then he quickly popped the tempting morsel into his own stuffed jaws.

Grinning broadly at his own joke he taunted Stump again and again. Finally, tiring of the play he sat back to contemplate his great wealth of food lying roasted in the pit.

"Hlimts haats" is still heard in our villages.
It is a teasing phrase meaning "I have something you can't have."

He was so busy admiring his accomplishment that he did not notice that the earth underneath Stump had begun to slide. Slowly, steadily Stump moved down the slope until he stood directly behind the pit full of bear meat. Too late We-gyet realized what was happening. In great alarm he shouted to Stump,

"Rest where you are, Noble Stump. Rest where you are!"

But Stump inched ahead.

"Now, now," We-gyet pleaded, "I was only having a little fun. Sit still. I will gladly serve you where you are," and he hurriedly chopped off huge chunks and threw them to Stump.

But Stump did not cease his quiet journey until he was over the pit. There he firmly rested, completely covering We-gyet's treasure.

Stunned and unbelieving We-gyet cursed his insolent tongue and sadly went on his way.

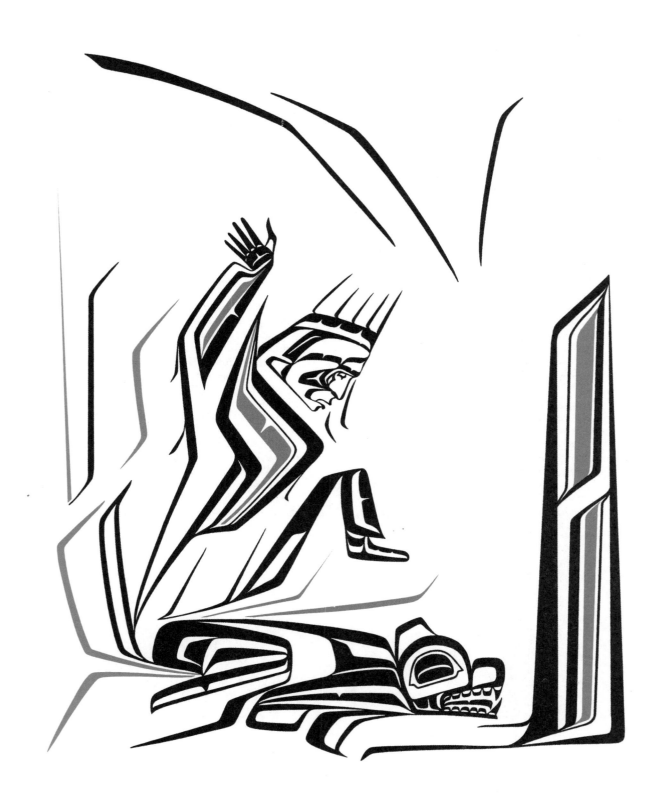

Andip'gan Gant Wii-gyat

Ii n'it wil gasligi luu midxwhl bans Wii Gyat. Hats'im t'aabeekwhl bant ii sim gant'xwt gasgoohl hla mitxw't ahl sim smax. Moojit k'eegumgat gasgoohl hla guuxwseexs Wii Gyat ii sim kya hisgiskitxws Wii Gyat gasgoohl hla ts'eext'.

Ii hasba'gyoot akhl ligi helhl goot dim wilt, needit kwihl stil' sil'gyat yukw dim gwin gyal'at gasgoohl hla guuxswil ootxwst iit xsi gya'ahl Andipgan dim liseewit.

Andipgan tun, kyaa wii t'ko'o't, ii gyap'xs, ii kyaa sip'xwt, hiin'il'xw wil sa litxw hla wisit, xsihul'ts'xwhl yip wil nii hetxwhl Andipgan sa, nit wil' sagaskotjis Wii Gyathl kyax iit ho yal'im gindihl Andipgan sa, Hlimts' haats' diya iit ho widnsinooshl Andipgan sa iit ho luu magit' ahl ts'imaakt. Hots'imo sa kots'dithl kyax hots'imo het, Hlimt's haats, diya hots'imo widnsinooshl Andipgan iit hots'imo luu magat' ts'imaakt. Gaswil ts'ahlxt, lip hal'aagixat sgwatxwt, gasgohl hlat sinookl Andipgan sa.

Ii gwalimligi hlap'ixswt gan'akwhl anrha'ost Andipgan sa ii ts'ihl t'aat, iit t'ilxhotxwihl gasgoohl hla ama wilt ahl smax. Ii needit gabidn'hl wil sageexwhl Andipgan sa.

Sii ligigyu'un da gya'as Wii Gyat wil hagwun' yukwhl Andipgan sa, gawil skihl tka sa angwat. Iit luuhlxum baxs Wii Gyat iit sik'ihl luuhl'xurh t'isihl wii amwistsa sim guuxsbax iit sagaskojihl kyax iit luuhl'xum m'it'axst. N'a, diyat Wii Gyat apukwihl yalyhl he'y diiya.

Hii yukwhl het ii n'iiakxwhl Andipgan sa lax sa angwat, ii kwihl hlaxhlaksat hlidaaxhl amwistsa gasgoohl hla getxwa bakt mooja'p waat'xwt wil anjahlxwt ahl tka bax kyeekwsithl smax.

Nit ganwihl needi an'his weesxwhl gyat ahl wineex nda wilt wat, needy an m'aost loot.

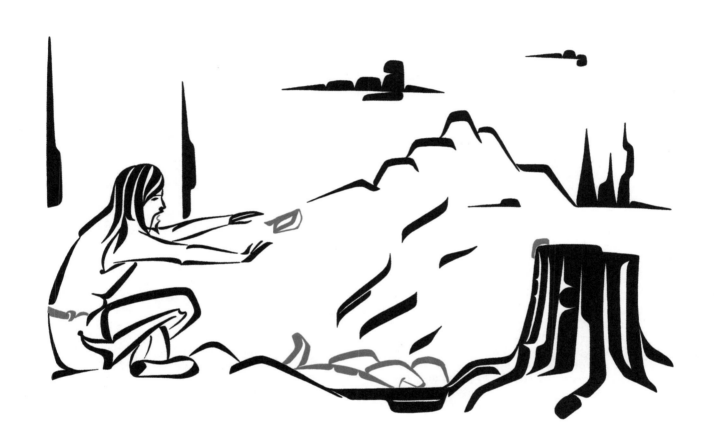

We-gyet and Water

We-gyet travelled on. At that time there were no rivers, no lakes, no creeks, no springs. The only water in the world belonged to Gwis Skee. She kept the unique water in a woven, water-tight spruce root basket. Gwis Skee never let the basket out of her hands, day or night. She herself held the basket for those who drank from it. No matter how many times she gave people a drink from the basket there was always plenty of cool, clear water left in the water-tight container.

We-gyet wanted the water. He made a plan.

He went to the village of Gwis Skee and found the house where she lived.

Faithfully following every law of etiquette We-gyet introduced himself to Gwis Skee as a chief from a distant land.

"Noble Lady, I have travelled from my far country for the honor of seeing the unique water. One sip of the renowned water would make glad my heart!"

Gwis Skee, charmed by the courteous behaviour, gladly held the water basket to the visitor's lips.

We-gyet drank and drank and drank. It was good manners to show appreciation by consuming large quantities and We-gyet took full advantage of the custom.

"Noble Lady, it is small wonder that the water is famous. I am weary from my long and difficult journey. May I rest myself for the night in a corner of your beautiful abode, a humble corner, far from the fire's warmth?"

Generous Gwis Skee promptly found a new sleeping mat for the Courteous One and placed it close to the fire. (Such a polite nobleman should lie close to the fire, she decided.)

We-gyet waited until Gwis Skee and all in the house were asleep. (Even in her sleep Gwis Skee held the basket tightly.)

We-gyet chewed some bark into a pulpy, brown mass.

He crept over to Gwis Skee's sleeping mat and smeared the chewed, brown bark on the mat behind Gwis Skee. Then he shook the woman by the shoulder and in a voice filled with shock and concern he whispered,

"Gwis Skee! Gwis Skee! Wake up!"

Gwis Skee woke with a start.

In a horrified whisper We-gyet continued, "Gwis Skee, look! You have soiled your sleeping mat!"

Gwis Skee hoped that she was dreaming. Her eyes followed We-gyet's pointing finger. It was no dream! She was ashamed. Ashamed. So ashamed.

We-gyet whispered soothingly, "Gwis Skee, I'll help you. You go and clean up and I'll look after the water basket. Nobody needs to know what you have done. I will shield you."

Gwis Skee was loath to let go of the basket but she knew that if anyone learned about the soiled mat, no amount of wealth distributed at the Shame Feast would completely wipe out her disgrace. Reluctantly she placed the precious water basket in We-gyet's hands and left to clean herself and her bedding.

Whereupon Courteous We-gyet quickly slipped

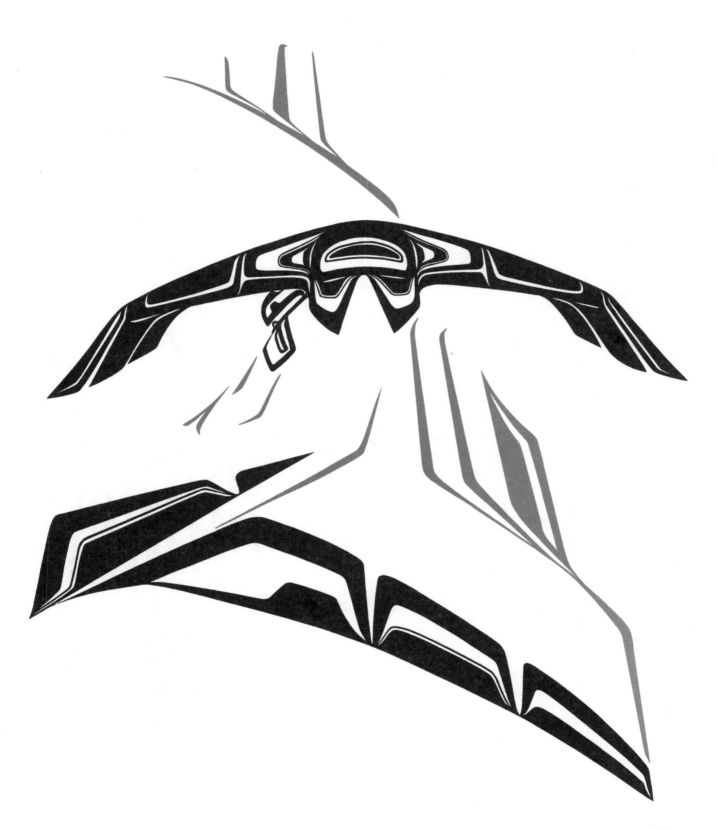

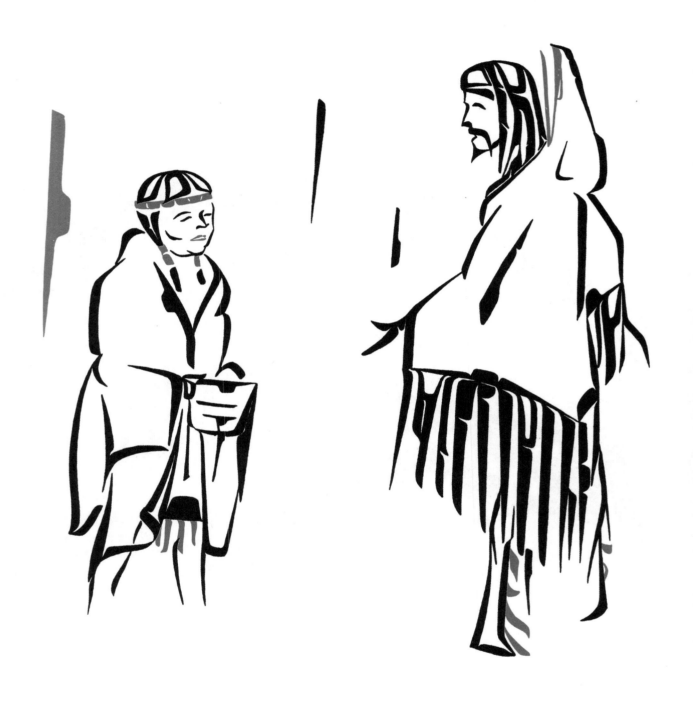

into his raven blanket, grabbed the basket firmly and soared out of the smoke hole and off over the village.

"That's We-gyet! He's got Gwis Skee's basket," shouted an observant villager who raced after We-gyet. The rest of the villagers joined the chase.

We-gyet saw what was happening. He spilled a little water saying, "You will be a nice, fresh spring — and the villagers will stop and drink you while I fly safely away."

As We-gyet predicted, the villagers stopped to enjoy the spring's water while We-gyet flew out of sight.

As he flew he spilled water here and there saying, "You will be a river," or "You will be a lake," or "You will be a creek," or "You will be a spring."

And that is how our rivers, lakes, creeks and springs began.

We-gyet was entranced with his new possession. Slowly he glided over the land, forming a lake here, a crooked river there, a rushing stream or a small brook.

With childish delight he spread the water; the beautiful, refreshing water we enjoy today — a priceless legacy from We-gyet.

Wii-gyat Ganhl Aks

Ii k'wilhl yees Wii Gyat, sim gwal'gax, hats'im gos ji hlokasxwt, needi yagayt gol'ligi ax'aks ligi nda. Am'k'yul' hanak si wat'diit as Gwis Sgi wil skihl aks. Luu gats' k'yaa gagetxwm aks t'un ahl ts'im hlgwa'al't.

Ts'aa ligi n'da ẏhl gabihl an't luu aks gwanksxws Gwis Sgi ii ap' needimdi luu goodit, yukxwhl aks ligit na iit ap' daxyugwis Gwis Sgi gasgoohl hla sigageetxwhl aks luu skit loot. Ts'aa axxwi ii apt daxyugwis Gwis Sgi ahl wokt.

Nax niẏs Wii Gyat wil luu skihl aks as Gwis Sgi ii sigootxwt dim wila xbagoodihl hlgwa'alt wil luu gats'hl aksxws Gwis Sgi iit w'as Wii Gyat wil joks Gwis Sgi lax gal'ts'ap. Ii hagwin yeet loot ii hot'ẏ hasakt dim akst, iit gins Gwis Sgi nit ahl aks.

Hlaa yuxwsa ii goya hasaks Wii Gyat dim lakya w'ogat' iit an'ook's Gwis Sgi iit aw's guus Gwis Sgi xwdaam ol'. Iit giba's Wii Gyat dim woks Gwis Sgi ii hagwin t'ka'at'xwt gawil giihls Gwis Sgi naadiit sim ts'im lax oot'xws Gwis Sgihl aksa ahl hiwokt.

N'it wil ge'en's Wii Gyat maasa gan iit w'aats xwhlii hil'eexs Wii Gyat han'i giihls Gwis Sgi tgas gyuksint, ii het ahl am xst'inxhlt yujwhl kw'ajn' Gwis Sgi, ii asigwis Gwis Sgihl het, hi yeediit dal'dis Wii Gyathl het yukwhl kwajn' Gwis Sgi nit wil hes gas Gwis Sgi ts'eekwan' diiyat Gwis Sgi.

Il han'ii goots Gwis Sgi ja xsi-wokt hehl nax niẏt iit gya'ahl gwii seekws Wii Gyat naadiihl needi xsi wokt ii sim han'axt ahl wilt.

Il hagwin tka'atxws Wii Gyat iit luu xst'inxhl ts'im muxws Gwis Sgi ii het dim hlimooẏ ṅiin, yukwmaja saksinhl xwdaaṅst, dim iin ka yugwihl aksis lun, ii neediit na dim an't wilaaxhl ṁiwil'laagwil xwdaanist.

Ii ap' needi hasaks Gwis Sgi dimt gal'ohl hlgwa'alt wil luu gat'shl aks. Iit wil'aaxs Gwis Sgi wil ts'aa ligi ndaẏhl gasgooh dim goodiit ja l'il'git't, ii ap' needim di sasak'sxwhl jookx nii skit loot. Sii ligi gyu'un da an'oogit dim t'klam dax yuugwis Wii Gyat hlgwa'alt wil luu gatshl aks, wil'kiit luuhlo'otxw Wii Gyathl gaak iit xsi yux'whl ts'im ganxsil'kw, xsi t'ka yukxw diithl wil luu gats'hl aks.

N'itwil gehlxxw hla kyul'hl hla gyadihl ts'ap did-aauihlis Wii Gẏathl aks, nit wil saa gol, ant hilan's Wii Gyat. Kwoo w'at's yukw k'widimoo sil'odiit iit ho gats'ihl aks iiy'oo het', dim gwanks ṅiiṅ dii ẏa, ii ẏoo wil'ki luu gats'diihl aks, dim ba'am aks ṅiiṅ diiẏa ii ẏoo wil'ki baxdiihl aks, dim t'ax ṅiiṅ dim'ẏ luu hoendn diiya ii ẏoo n'ithl wilt dim luu simil 'o'ot ṅiiṅ diiya ii nit'hl wilt.

N'it ganwilhl gol'hl aks gwanks ganhl t'ax lax sa tun.

We-gyet and Haa

We-gyet wandered on.

He came to a strange, empty village.

He walked by the houses but he saw no one, he heard no one, nothing but the wind rustling and whispering.

S-s-s-s,h-h-h-h,s-s-s-s,h-h-h-s-s-s-s,h-h-h-h,s-s-s-s,h-h-h.

He thought he smelled the delicious odour of boiling, mountain goat meat. The mouth-watering scent seemed to come from the house that stood in the middle of the front row of houses, the main chief's house. We-gyet quickly entered that house.

We-gyet was right about the boiling mountain goat meat. A big wooden cooking box stood by the fire. The box was full to the top with goat meat simmering invitingly.

We-gyet decided that the odour was ample invitation, so without waiting for the owner to serve him the Big Man grabbed for some of the meat.

Crack! A stick appeared and swatted his fingers. No visible person held the stick but We-gyet was in too much pain and too hungry to worry about who held the stick. We-gyet ignored the hurt, he ignored the stick and he ignored a food mat that, seemingly, moved itself into position at the place of honour. He was starving. Nothing else mattered.

We-gyet grabbed again.

Crack!

The stick hit his fingers at the second joint, or where that joint is today.

We-gyet's fingers throbbed but his stomach craved that goat meat! He reached out again and again. Each time the stick-with-no visible-holder hit him and each time he was hit a new joint was made; the fingers, the wrist, the elbow.

We-gyet became as angry as he was hungry and that was very angry. (The robber resented being robbed.)

"Who are you, Thief, that keeps this meat from my empty belly?" he roared in what he considered justifiable indignation.

There was no answer, just the rustling of the wind. SSS-s-s-s-s-h-h-h-h, s-s-s-h-h-h, s-s-s-huh-huh-huh.

We-gyet listened to the 's-s-s.' That sss-s-s-s-huh-huh-huh sounded very much like stifled laughter. Now that he listened carefully he realized that it *was* laughter and that there was chatter too. It seemed to come mainly from the chief's quarters at the back of the great house.

S-s-s-ha-ha-ha. S-s-s-ha-ha-ha.

We-gyet stomped over the chief's area and thumped angrily on the wooden partition which divided the chief's quarters from the rest of the house.

"Stop that noise!" he bellowed.

The sounds became distinct. There was no mistaking them now, they were the sounds of teasing, satirical laughter. We-gyet thought he knew the name of the chief.

"Chief Haa," We-gyet shouted, "Is it you who starves me?" (*'Haa'* means 'wind' in our language.)

From behind the partition and from all around the house came the rustling, whistling, whispering taunt,

"Who doesn't know you, We-gyet! You will not empty our food boxes, Wooden Ears!" *

Cradling his painful new joints above his empty stomach, We-gyet plodded on his way.

* "Wooden Ears," means someone who will not learn. Before writing was known to our people they had to use their ears to learn.

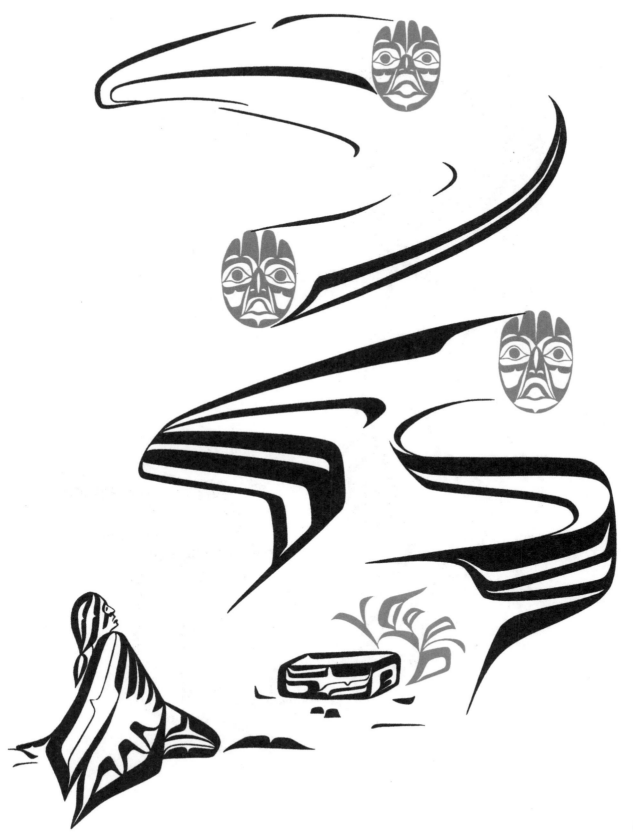

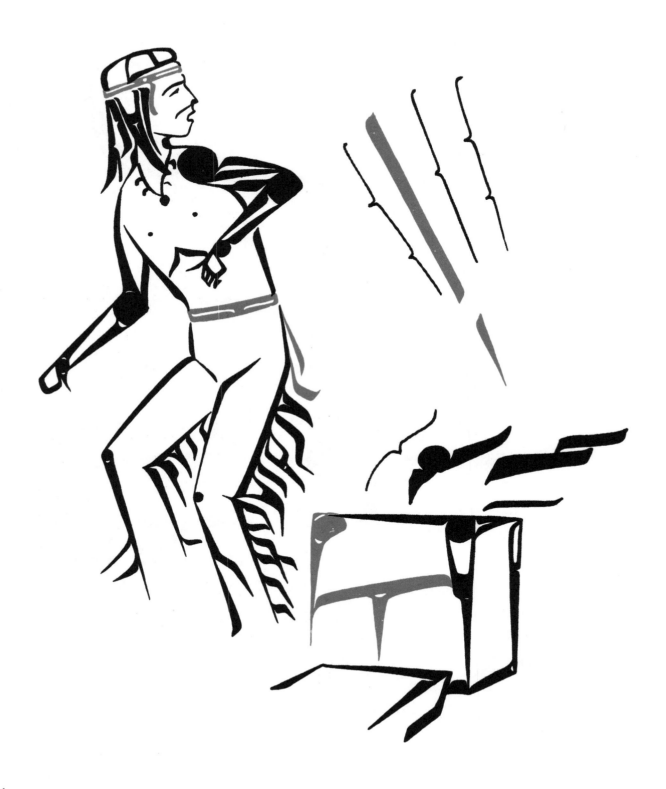

Wii-gyat Ganhl Ha

Ii kwihl yees Wii Gyat ii w'ahl hla ḵap'hl ts'ap ii neediit naa ji gya'at, amxsa bahaasxwhl naxniẏt.

Han'ii goot't jit haneegihl jam smaaya matx hats'im hlokxwit hla yahlxt. Hats'im gal'gol' hla xsinaaḵs Wii Gyat wilt haneegahl gasgoohl hla miiyuxws jam smaaya matx, ii yeet goohl kiẏhl wilp ii ts'int nadihl ẇii enḵ skit lax ts'eehl lakw, si amhl hahlutaxwt, sim luu mitxw ahl smax.

Needi am ligi giigidagasxws Wii Gyat dim hats'imligi sbat'ogathl smax diiyahl het, hloo'ohl ont, sim xts'iiyats'diit k'ila'at, neediit naa ji gya'at ji ant yugwihl gan.

Gal' siipxw hla xwdaxs Wii Gyat dimt sik'ihl gyaadihl naa ja'ant yugwihl gan, hots'imo hlo'ohl an'ont, hots'imo xts'iiyats'diit. Sim aḵwildiit hoox wil sk'ihl han'ii sganahl wilt bagalgi ama sgitxwsit dim han'ii taat gal'xwdax nit. Mahla k'iy'hl yeehl an'ont yoo yats'xwt. Nit ganwihl luu yihl yahlxw gats'uuwilint, kil'a'a ganhl sganst lax sa' gyuu'n.

Sim lukwil siipxwhl goots Wii Gyat ii sim dal'hl Wii Gehlxxwt wil hla neediit da'aḵxwhl dimt guuhl

hasaḵt. Naa n'iin'ist w'ats' logam hat'akxw dim gan'a luumitxwhl ts'im galoosdy' dii ya.

Neediit naa ji dilimxxwt, ḵamxsa bahaasww nax n'iy't. Hats'im luudkwa kiits'ilxsxw ts'im wilp. Hehl ap ts'ahlxadiihl bahaaxxw wil nax nit, ii wat's ama nax n'isxwt, naadihl ap ts'ahlxhl nax niy't t'weeksxw'ehl hehl al'al'gyagat'diihl het, iit skwina nax n'is Wii Gyat goohl ts'im pdo'o wil huu hehl. His halaagyaxwid. Neegyoo di biixsinḵxw't, han'ii goots Wii Gyat jit wil aaxhl het gi ii sim d'ahlhl ee'asxwt. Bahaasxw, dii yat Wii Gyat neehl n'iinhl wilt ant aaduxwẏsa. Goohl gado'ohl pdo'o ganhl tḵa nit'xws ts'im wilp. Six sakwsit jabhl Bahaasxw, hats'im gitẇinḵ ii kuuts'ilxsxw.

Naa ant at'dy wila'an', Wii Gyat. Neediit n'iin dim ant luujihl jahl engam wats, muxwhwms gantxw.

Ii hotsim kwihl yees Wii Gyat gay nithl ẇaa'yt luu hihl yahlxwhl anont.

Nee diit naa ja has'xst'aad ahl dim ḵasba dogaat.

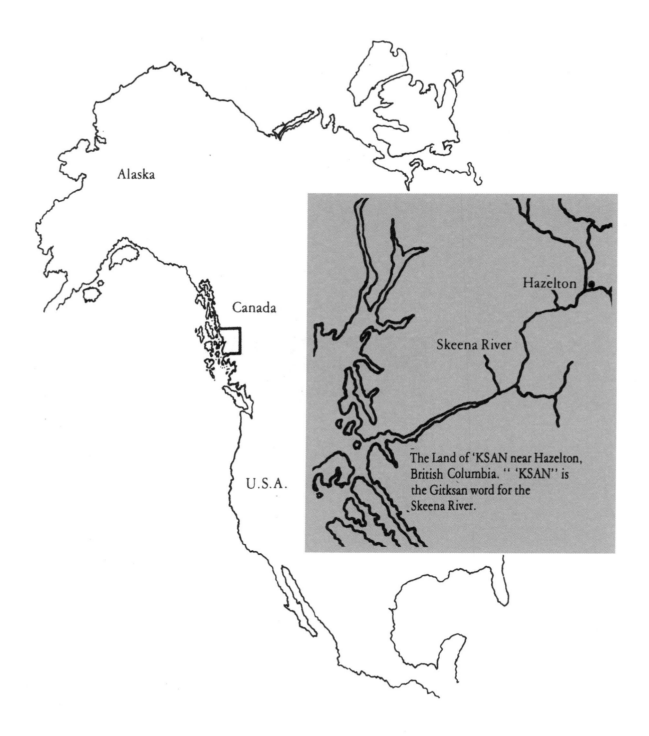

Alaska

Canada

U.S.A.

The Land of 'KSAN near Hazelton, British Columbia. " 'KSAN'' is the Gitksan word for the Skeena River.

Hazelton

Skeena River

'KSAN

'KSAN is an Indian Museum and Craft Village in the mountains of North Central British Columbia.

Because the territories of our chiefs are far from the early routes of the settlers and missionaries, we of 'KSAN still hold much knowledge of the histories, legends and ways of our great great grandfathers. Our people have lived in the land of 'KSAN for over six thousand years.

For countless generations our store of knowledge was passed on by the spoken word. Tribal histories and laws were taught with stern accuracy of detail but the ordinary stories and legends were often colored by the personality of the storyteller. A bloodthirsty person emphasized the cruel and frightening, a gentle, witty person brought out the humor and compassion. Some storytellers forgot details, others invented them. Thus today we have many versions of the same adventure. Each is basically correct. From these interesting variations we have written a single version, using details that are accepted by the majority of our knowledgeable elders.

In 1971 some of 'KSAN's people, aided by a Government grant, taped, transcribed, translated, filed and cross-filed all they could glean of the way of the land of 'KSAN in the days of the grandfathers. The results encouraged the group to persist in their quest until today a surprising wealth of information has been amassed. We have it in our hearts to build this wealth into several lively and informative publications. "We-gyet" is our introduction.

We acknowledge with loving gratitude the wit and wisdom of our ancestors who must surely smile from the distant shadows of our past as we record the stories which they created.

We hope that our versions will jog the memories of our own people so that they may recall additional details to add to that treasury of humor and humanity, the legends of We-gyet.

The Book Builders of 'KSAN
Hazelton, B.C.
July 3, 1977

Artists

The 'KSAN Book Builders

Charlotte Angus
James Angus
Norma Barnes
Richard Benson
Mary Blackwater
Martha Brown (Hazelton)
Martha Brown (Glen Vowell)
Abel Campbell
Edith Campbell
Joshua Campbell
Freda Diesing
James Fowler
Marie-Francoise Guedon
David Gunanoot
Fred Good
Rufus Good
Chris Harris
Clara Harris
Sadie Harris
Ernest Hyzims
Lorraine Jack
Solomon Jack
Alice Jeffrey
Doreen Jensen
Charles Johnson
Ellen Johnson
Evelyn Johnson
Fred Johnson
Gideon Johnson

Peggy Morgan
Wallace Morgan
Willis Morgan
Elsie Morrison
Gertie Morrison
Moses Morrison
Steven Morrison
Arthur Mowatt
Jane Mowatt
Mary Mowatt
Sophia Mowatt
Esther Muldoe
Lottie Muldoe
Shirley Muldon
Edith McDougal
Mary McKenzie
James McRae
Maggie Johnson
Mary Johnson
Louise Joseph
Emily Latz
Sarah Marshall
Connie Milton
David Milton
George Milton
Johnny Moore
Geoffrey Morgan
Jack Morgan

Irene Ness
Irene Patsey
Olive Ryan
Arthur Sampson
Perry Sampson
Eva Sampson
Frances Sampson
Mary Sampson
Polly Sargent
Barbara Sennott
Fanny Smith
Art Sterritt
Barbara E. Sterritt
Jessie Sterritt
Patsy Sterritt
Charles Stevens
Russell Stevens
Agnes Sutton
Agnes Travers
Cliff Weeks
Alice Williams
Johnson Williams
Doris Wilson
Gordon Wilson
Laurel Wilson
Marie Wilson
Walter Wilson
James Woods
Henry Wright

Sandy Heybroek